IMAGES
*of Rail*

# PORTLAND'S STREETCARS

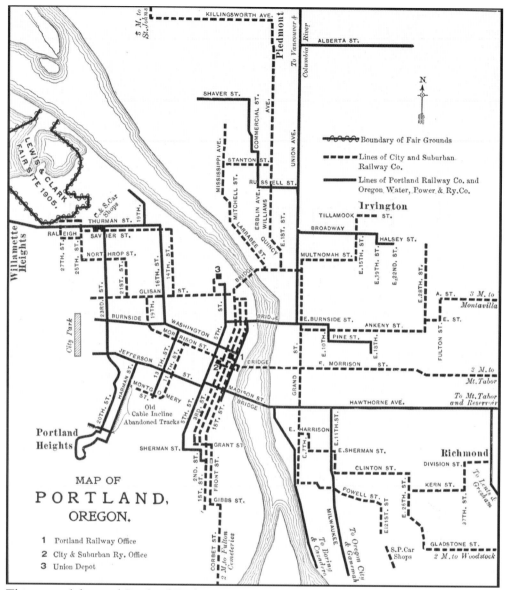

This map of the rival Portland Railway Company and City & Suburban Railway Company lines appeared in the *Street Railway Journal* in 1904. The cable car line to Portland Heights had been abandoned, and work had begun on the Lewis and Clark Exposition grounds in Northwest Portland. In the run-up to the exposition, both companies were furiously building new lines, creating a pattern that would last throughout Portland's streetcar era.

ON THE COVER: Portland's streets were never more full of streetcars than in this 1905 view on Southwest Morrison Street at Third Avenue. A string of open motors, three blocks long, are loading delegates for the Kitchen Range Convention at the Lewis and Clark Exposition. The buildings on the right survive today as Borders Books and the Rock Bottom Brewery.

IMAGES
*of Rail*

# PORTLAND'S STREETCARS

Richard Thompson

ARCADIA

Published by Arcadia Publishing
Charleston SC, Chicago IL, Portsmouth NH, San Francisco CA

Printed in the United States of America

Library of Congress Catalog Card Number: 2005937815

For all general information contact Arcadia Publishing at:
Telephone 843-853-2070
Fax 843-853-0044
E-mail sales@arcadiapublishing.com
For customer service and orders:
Toll-Free 1-888-313-2665

Visit us on the Internet at www.arcadiapublishing.com

*Dedicated to my friend William K. "Bill" Hayes.*

# CONTENTS

# ACKNOWLEDGMENTS

This book would not have been possible without the efforts of my friend, the late William K. Hayes. Bill's lifelong love of streetcars began when he rode them as a boy during the 1920s. He began collecting images and memorabilia in 1971. I joined him in the project one year later, the end result was an archive consisting of over 5,000 pictures, clippings, and articles relating to Portland Traction history. While I focused on organizing prints and negatives, Mr. Hayes did the heavy lifting, contacting former transit employees and perusing estate sales, garage sales, and antique dealers.

During my 18-year stint as editor of the Oregon Electric Railway Historical Society's newsletter, *The Trolley Park News*, Bill drew upon this collection and his own personal experience to contribute a dozen articles on local streetcar lines. Throughout it all, he encouraged me to find a way to share this collected material with a wider audience.

It has been my good fortune both to have ridden the last Portland trolleys as a child and to have been intimately involved in the efforts of the late William Naito to bring trolleys back to life through the formation of Vintage Trolley, Incorporated, in 1991. I have also been privileged to count three of the last living motormen—Chuck Hayden, Al Nelson, and Gene Watson—among my friends. Their memories, like those of Bill Hayes, provided me with living links to Portland's railway history.

I wish to thank the following individuals, many of whom are now deceased, for their contributions to this project: Roy Bonn, G. Charles Bukowsky, George Chope, James Freeman, Mary A. Grant, H. Lawrence Griffith, Alfred L. Haij, Rosa Halemba, Charles E. Hayden, John T. Labbe, Walter Mendenhall, Steve Morgan, Mark Moore, Mike Parker, Earl B. Richardson, John Schmitt, Charles C. Snook, Thomas Stanley, Vernon L. Thomas, Edward E. Vonderahe, and James West. Thanks are also due Susan Seyl of the Oregon Historical Society for her invaluable research assistance. Finally, I want to thank my wife for proofreading, keeping visitors at bay, and for tolerating the mood swings brought on by hours of research and writing.

Unless otherwise noted, all pictures in this book are from the author's personal collection. Original photographers are cited wherever possible.

—Richard Martin Thompson

# INTRODUCTION

Through five generations, the lines of more than 40 street railway companies have served Portland, their history filled with superlatives. Portland's first electric railway began operating in 1889, less than a year after Frank Sprague demonstrated the first successful trolley system in Richmond, Virginia. In 1890, a cable-car system, with the second-steepest grade in the country, opened here. The first true interurban line began running between Portland and Oregon City in 1893. During this same period, Portland boasted the largest electric street railway system in the West. It would grow to be the third-largest narrow-gauge operation in the United States.

The late 19th century was a boom time for Portland. The city had finally won connections with transcontinental railroads, and its industries were developing rapidly. More jobs and more people had created a rising need for transportation.

The first company to engage in mass transit was the Portland Street Railway, which enjoyed a 10-year, horse-drawn streetcar monopoly, starting in 1872. By 1888, it was joined by a half-dozen companies with horsecar lines extending to both sides of the Willamette.

By 1887, when the Willamette Bridge Railway introduced the first machine-powered public transportation system in town, the pioneering horse-drawn systems were struggling with increasingly longer lines. The steam "dummies" of seven companies provided a solution, pulling trains of former horsecars out to Mount Tabor, Vancouver, St. Johns, Woodstock, and West Portland.

In 1890, after months of delay, the Portland Cable Railway Company added another refinement to the local transportation scene with cable cars built by the company that provided them to San Francisco. The Portland cable line was steeper, and it provided service through snow and flood when other forms of transportation failed. Few suspected that, in a few years, cable transit would also be obsolete.

In 1889, the first electric railway in Oregon was completed from the west end of the Steel Bridge into Albina. The new trolleys, making use of the latest scientific advances, were fast, quiet, and nearly pollution free. Uniformed men operated these symbols of progress effortlessly, with just the twist of a handle.

The flurry of spending on electric streetcars was interrupted by the Great Panic of 1893. Several local railway companies went bankrupt, while others were absorbed by consolidation.

By the time Portland Railway, Light & Power took over all local railways in 1906, the last steam line had been converted to electricity, and trolley poles had sprouted on the roofs of former cable cars. During its first year of operation, over 60 million streetcar trips were made. The neighborhood patterns forged by trolley tracks can still be seen on city road maps.

The trolley had become more than a means of transportation; it was a social phenomenon. During Portland's streetcar era, people rode trolleys for recreation as well as transportation. On hot summer evenings, families cooled off with a relaxing ride in an open car. On Sundays, the streetcar took them out to the country for hiking, picnicking, fishing, or to enjoy rides and dancing in new trolley parks at Council Crest, The Oaks, Canemah, Cazadero, and Columbia Beach. There was even a trolley hearse to take patrons on their final ride.

The automobile first appeared on Portland streets in 1898, but decades would pass before a significant number of Rose City residents could enjoy the freedom and status conveyed by owning one. Although America's growing love affair with the automobile certainly contributed to the demise of street railways, other factors, including heavy debt, franchise demands, rising labor costs, and a populist backlash against big business, also played a role.

The first threat to streetcars came in 1914 when jitneys, unregulated taxi-like vehicles, began prowling trolley routes to pick up willing riders ahead of streetcars. Litigation reached all the way to the state supreme court before city ordinances finally made jitneys unprofitable.

In 1924, the traction company placed its first order for gasoline buses. However, they operated on crosstown or stub lines. Buses did not begin to replace streetcars on major routes until 1936, when Portland Traction placed a record order for trolley buses.

Streetcar ridership began to drop in 1920, a decline that was halted only briefly by World War II. The last city cars ran in 1950. In 1958, in defiance of PUC orders, Portland Traction Company terminated the remaining two interurban lines. They wanted to sell to mainline railroads desiring freight-only operation.

When the final ragtag fleet of 16 secondhand cars stopped running, Portland was without streetcars for the first time in 85 years. It seemed that the time of the trolley was gone forever, however, 30 years later, city planners would reinvent them.

The full story of this adventure is beyond the scope of this book. The intent here is to provide a glimpse at a bygone age and to foster an appreciation for the contribution the streetcar made to everyday life. Carefully selected images, most never before published, take the reader on a journey through the pioneering days of mass transit in Portland. Clang, clang . . .

# One

# BEFORE THE TROLLEY
## 1872–1888

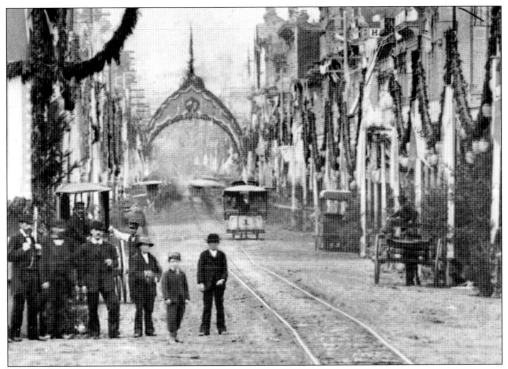

Portland's first streetcar line was Ben Holladay's Portland Street Railway of 1872, a horsecar operation, which ran on single trackage along First Avenue in downtown. In what may well be the oldest extant photograph of a Portland streetcar, No. 1 runs on an unpaved First Avenue. The street was decorated in commemoration of the completion of the Northern Pacific Railroad in September 1883. Eight new double-ended cars had just been added to the system, along with passing tracks like the ones in this photograph.

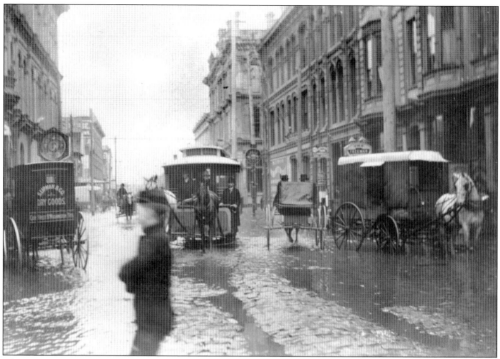

This view of a Portland Street Railway horsecar was taken in February 1890, five years before the city's first streetcar line suspended operation. By this time, the operation was moribund, and Ben Holladay's heirs were unable to find the investors needed to convert to electric operation. Portland's original horsecar line would also become its last. Note the rails sunken into the cobblestones, evidence that the tracks came before the pavement.

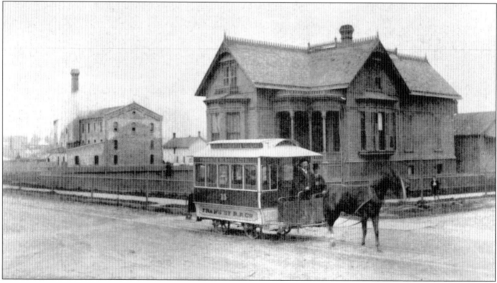

The Transcontinental Street Railway began horsecar service in 1893 with the most optimistic railway company name of them all. This view of Car No. 15 was taken in an industrial section of the Glisan Street line during the first years of service. The letter board beneath the Bombay roof reads, "Third and G Streets."

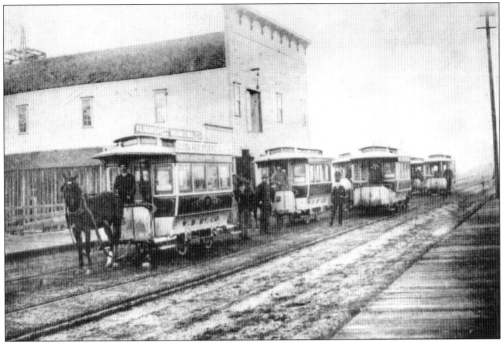

These Willamette Bridge Railway horsecars are gathered in front of their barn on Southeast Morrison Street at Grand Avenue around 1888. The company wanted to build a steam motor line but was limited by its franchise, becoming the sole horsecar operator on the eastside. The line, linking Portland and East Portland across the new Morrison Street Bridge, was successful until a barn fire in June 1890 precipitated conversion to electric operation.

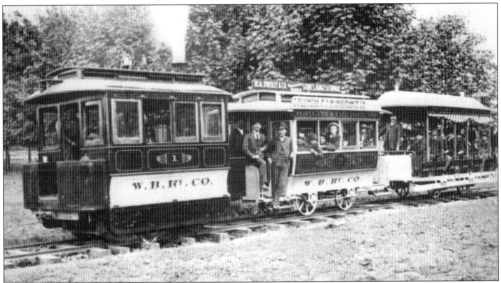

This quaint train was Portland's first venture away from animal-powered public transportation. The location would be near present-day Southeast Belmont Street in the vicinity of Thirty-fourth, probably at the inauguration of service in July 1888. The cars pictured with the steam dummy engine were originally horsecars built by J. S. Hammond and Company of San Francisco. (Courtesy Oregon Historical Society, ORHi 3676.)

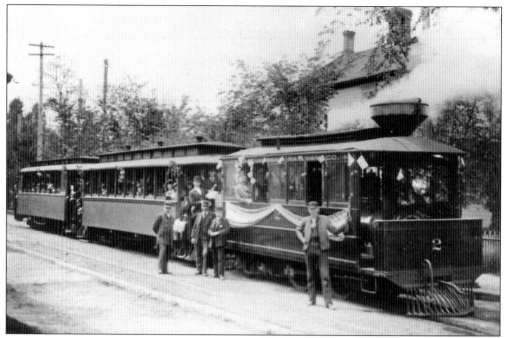

Willamette Bridge Engine No. 2, now lettered for the City & Suburban Railway Company, is at Southeast Sixth Avenue and Morrison Street, the East Portland terminal of the Mount Tabor line. Bunting and flags indicate a festive occasion, which may well have been the inauguration of C&S service on September 3, 1891. A period of consolidation began when the Transcontinental Street Railway and the Willamette Bridge Railway companies merged to form the C&S.

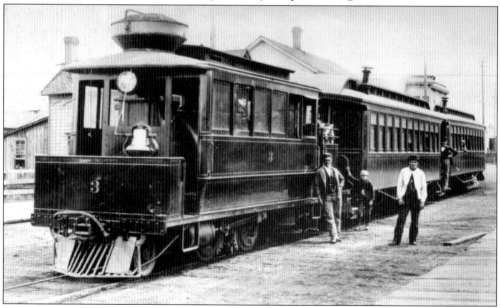

Portland & Vancouver Railway Motor No. 3 and two coaches are pictured here at the East Portland landing of the Stark Street Ferry, the southern terminal of the line, c. 1892. This train met the ferry that crossed the Columbia River at Hayden Island for Vancouver, Washington. Service was provided at 30-minute intervals.

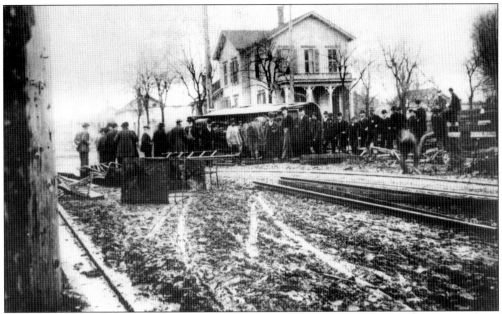

Possibly the first fatal accident in Portland transit history, and the only one on a dummy line, occurred April 4, 1893, when the throttle stuck on a Portland & Vancouver Railway steam dummy, causing it to derail on the curve at present-day MLK and Northeast Couch. Engineer John Hans was scalded and did not survive. Two weeks later, the line was electrified. (Courtesy Oregon Historical Society, ORHi 35762.)

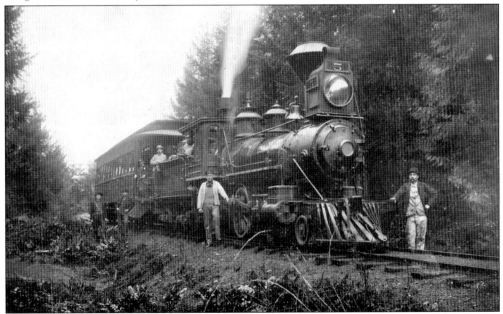

In December 1890, engine No. 5, a regular steam locomotive, was placed in service on the St. Johns line so that steam dummies could be transferred to the popular Mount Tabor line. The regular crew of the 5 Spot was engineer Frank Smith, fireman Hally Perry, and conductor Thomas Monahan. Monahan and Smith later made the transition to electric cars, but Perry went to work for the OWR&N, a mainline steam railroad.

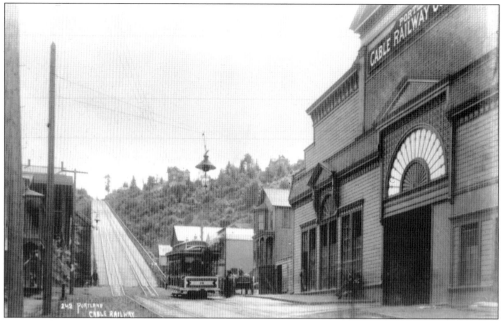

In 1890, after months of delay, the Portland Cable Railway Company added another refinement to the local transportation scene with handsome cable cars built by the same company that provided them to San Francisco. The ornate Portland Cable Railway carbarn, shops, and powerhouse were located at the bottom of the Chapman Street incline near present-day Southwest Eighteenth and Mill Streets. Powerhouse capability was designed for an expansion westward to Beaverton but was never built.

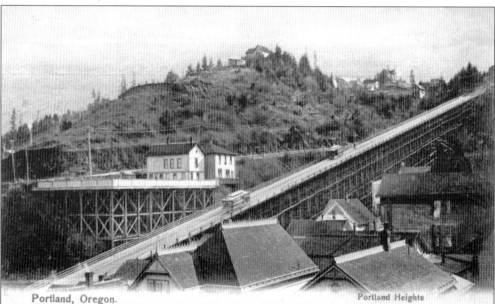

Portland, Oregon.                                                                    Portland Heights

With a grade of 20.93 percent, Portland's cable incline was the second steepest in the country. This local landmark took two months to build and was 1,040 feet long and 270 feet high. Too steep for any other form of transit, the cable ascent to Portland Heights remained in use for 14 years. In 1892, Pres. Benjamin Harrison rode the cable car up this incline while visiting Portland.

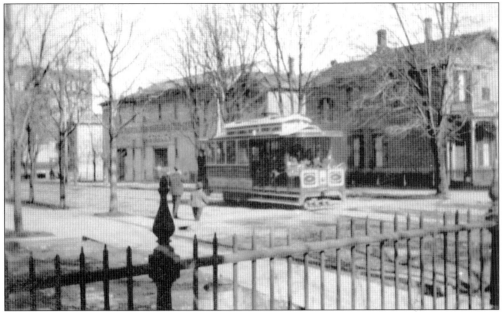

A Portland Cable Railway car is southbound on Fifth Street between Salmon and Taylor Streets around 1894, two years before most cable cars would be converted to electric operation. The Goodenough Building is at far left and the Frazier and McLean Boarding Stable is in the center. The iron fence in the foreground belongs to the Failing mansion. This scene would be unrecognizable today.

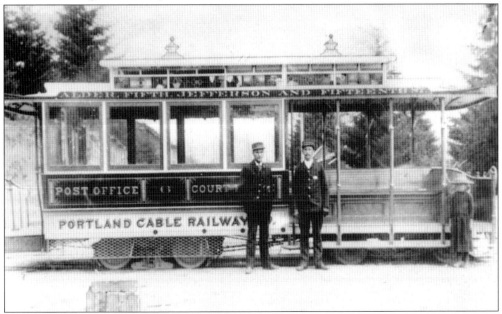

Portland Cable Railway Car No. 6 is pictured here at the Portland Heights end of the line on Spring Street in the early 1890s. The little girl at right was reportedly a Hewett, a family for which a boulevard was named. Signs on the side of the car refer to streets over which the line ran—Alder, Fifth, Jefferson, Fifteenth, then up the incline to Spring Street. The post office and courthouse building on Fifth Street survives today.

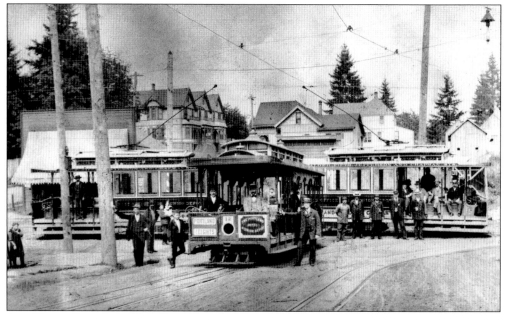

In 1899, two electrified cable cars meet a regular cable car in front of the carbarn at the intersection of Southwest Jefferson and Chapman. After 1896, only the incline remained cable. This allowed for a unique operation whereby some cars traveled to Chapman, hauled down their trolley poles, installed grips, and went up the incline! The cars had been modified by being raised eight inches and having motors installed on their rear axles.

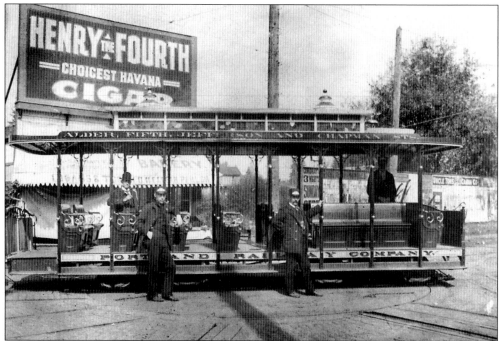

This 1901 image shows one of 10 Stockton open cars on the turntable at Southwest Jefferson and Chapman (now Eighteenth Street). In 1896, Portland Railway became the last company to operate cable cars in Portland. They immediately began planning for conversion to electric cars.

# _Two_

# EARLY ELECTRICS
## 1889–1904

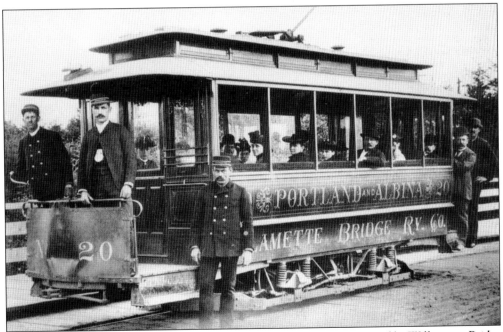

The first electric line in the state was the Portland and Albina route opened by Willamette Bridge Railway in November 1889. The initial mile of this pioneering line ran from the west approach of the new Steel Bridge to North Russell and Larabee Streets. Car No. 20 was the first of five trolleys ordered from the Pullman Palace Car Company. The dent in the dashboard was made by the kick of a horse, or mule, whose assistance was required when the rudimentary Sprague motor failed.

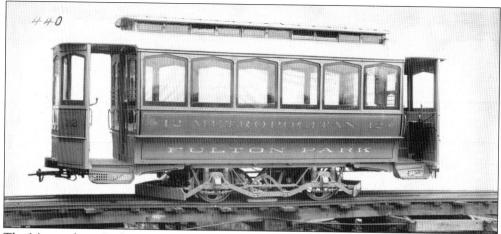

The Metropolitan Railway's electric line to the community of Fulton Park in South Portland was not far behind the Albina line. The first runs were made on New Year's Day in 1890. The No. 12, seen here in a Brill builder's photograph, is thought to have been one of six cars that inaugurated this first westside service. They were noteworthy for their green, cream, and red livery and enclosed platforms. (Courtesy Mark Moore.)

In September 1891, the first electric car to be built in Portland was added to the Metropolitan roster. The Heacock and Lovejoy single-truck trolley was a new combination design advertised as being "entirely changed from closed to open car in less than two minutes." Builder Vulcan Manufacturing, later Columbia Car and Tool, lasted only a few years but managed to build cars for several companies.

The third company to convert to electric operation was the Multnomah Street Railway, which began running trolleys in March 1890. Car No. 27, seen here on the Washington Street line during the first year of operation, was among the first cars ordered from Pullman and nearly identical to Willamette Bridge Railway's new streetcars. At this time, trolleys were permanently lettered for their lines, just as horsecars, cable cars, and dummies had been.

In 1890, a bevy of young ladies in the latest attire pose in front of the equally elegant Car No. 36 of the Multnomah Street Railway. In response to cooler weather, portable vestibules were attached to the dashboards. These small cars would soon be outdated, but several years hence, No. 36 would receive a stay of execution when chosen as one of eight single-truck Pullmans whose bodies were used as the center sections of large three-compartment cars built for the first Portland Railway Company.

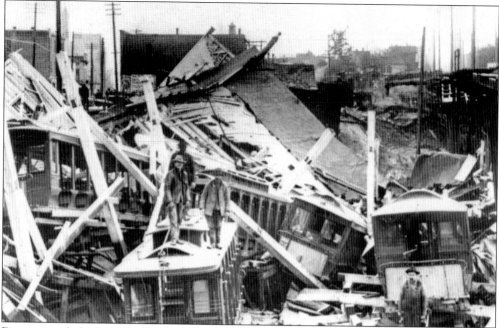

Disaster struck the former Multnomah Street Railway barn at Southwest Eighteenth and Washington Streets on March 19, 1904, when the Tanner Creek storm sewer caved in. Most of the cars were salvaged, however, and returned to service. Successor Portland Railway had already built a new barn up the street at Twenty-third Avenue and Burnside.

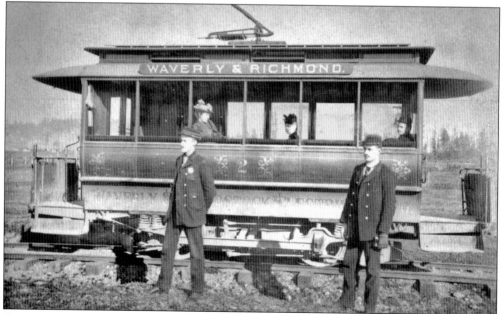

One of the original Pullman cars of the Waverly & Woodstock Electric Railway has paused while outbound on the Waverly-Richmond line around 1891. Mount Tabor is in the left background, and the Ladd farm, soon to become Ladd's Addition, is on the right. The W&WER was the last company to successfully inaugurate new trolley service. It was part of a real estate promotion through which tract owners were also stockholders.

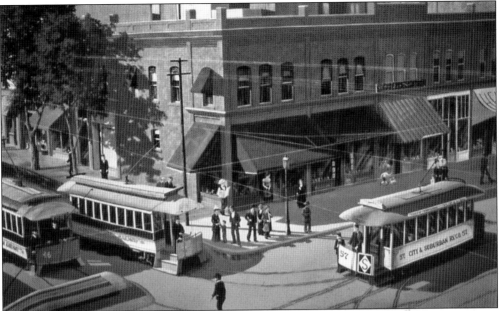

A period of consolidation began in 1891 when the Willamette Bridge Railway and the Transcontinental Street Railway merged, linking systems on both sides of the river. The new City & Suburban Railway, with more than 60 cars and 61 miles of track, became the largest electric railway in the West. This painting of their headquarters at Southwest Third Avenue and Yamhill Street is from a diorama by Portland artist Dale Varner.

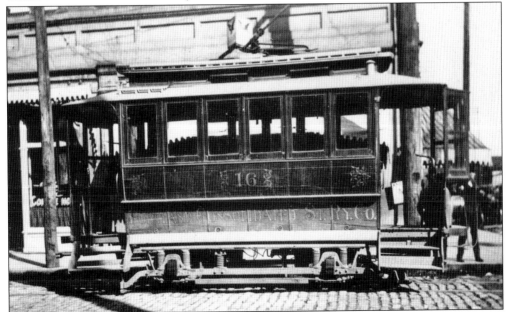

Just before the depression of 1893, George Markle's ill-fated Portland Consolidated Street Railway Company attempted to compete with the City & Suburban by merging the Portland Traction, Metropolitan, and Portland & Vancouver railways. Due to a nationwide shortage of cars, Consolidated acquired this little 14-footer, secondhand from New York City. (Courtesy Oregon Historical Society, ORHi 5683.)

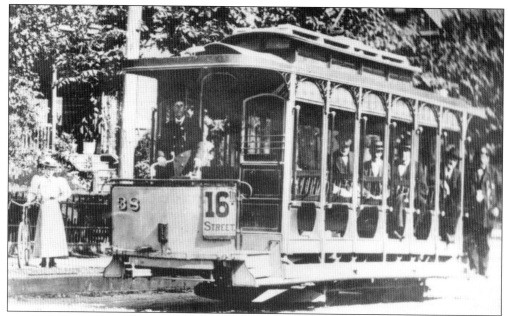

In a 1929 recollection, John A. Workman, the motorman at the helm of Car No. 38, described it as Portland's first open car. Multnomah Street Railway bought a series of these Low's convertibles in 1890 and soon rebuilt them as permanent opens. This photograph was taken in the summer of 1895 near Northwest Sixteenth and Davis Streets. By this time, the Portland Consolidated Street Railway was in receivership. (See page 25 for another picture of Mr. Workman.)

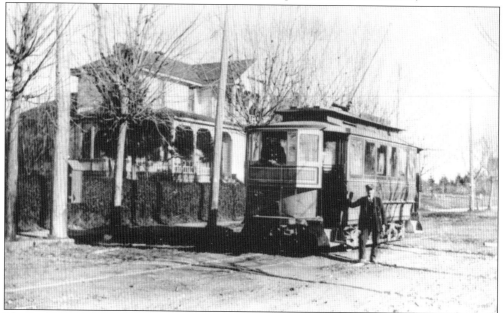

The Irvington line was one of the first six electric routes in town, as attested to by this c. 1900 view of former Willamette Bridge Railway Car No. 28 at the end of the line on Northeast Nineteenth and Tillamook Streets. Car No. 28 was one of three cars purchased from the Northern Car Company of Minneapolis in the fall of 1890 to inaugurate Irvington service. City & Suburban added the bay-windowed portable vestibules.

# City and Suburban Railway Co.

## TIME CARD.

Time Table showing when last car leaves for fifteen diverging points from Third and Morrison Streets.

All parts of the city and suburbs can be reached over the lines of the City and Suburban Railway Co.

### SAVIER STREET LINE.

Last car passes Third and Morrison Streets going south,  -  11:35 P. M.
"   "   "   "   "   "   "   " north,  -  -   12:00

### GLISAN STREET LINE.

Last car passes Third and Morrison Streets going west,  -  11:24
"   "   "   "   "   "   "   " north,  -  -   11:51½

### UPPER ALBINA LINE.

Last car passes Third and Morrison Streets,  -  -   -   -   11:33
"   " leaves Upper Albina Junction for Third and Morrison Sts., 11:10

### LOWER ALBINA LINE.

Last car leaves Third and Morrison Streets,  -  -   -   11:30
"   "   " Lower Albina Junction for Third and Morrison Sts., 11:30

### IRVINGTON LINE.

Last car leaves Third and Morrison Streets,  -  -   -   11:30
"   "   " Irvington for Third and Morrison Streets,  -  -   11:10

### HOLLADAY AVENUE LINE.

Last car leaves Third and Morrison Streets for Holladay's Addition, 11:15
"   "   " Holladay's Addition for Third and Morrison Streets, 11:00

### WOODSTOCK LINE.

Last car leaves Third and Morrison Streets for Woodstock,  -  11:15
"   "   " Woodstock for Third and Morrison Streets,  -  - 10:36

### WAVERLY LINE.

Last car leaves Third and Morrison Streets for Waverly,  -  11:00
"   "   " Waverly for Third and Morrison Streets,  -  - 10:35

### FAIRVIEW—EAST ANKENY LINE.

Last car leaves Third and Morrison Streets for East Ankeny,   11:00
"   "   " Mt. Tabor Villa for Third and Morrison Streets, 10:25

### MT. TABOR STEAM MOTOR LINE.

Last car leaves Third and Morrison Streets for Mt. Tabor,  -  11:15
"   "   " Mt. Tabor for Third and Morrison Streets,  -  - 11:05

### ST. JOHNS LINE

Last car leaves Third and Morrison Streets for St. Johns,  -  11:00
"   "   " St. Johns for Third and Morrison Streets,  -  - 11:30

**THIS SYSTEM IS OPERATED BY CAR DISPATCHER.**

**General Offices, - THIRD and YAMHILL STREETS.**

As can be seen from this 1892 timetable, during the first months of operation, the City & Suburban Railway Company operated nine trolley lines and two steam motor routes, reaching "all parts of the city and suburbs."

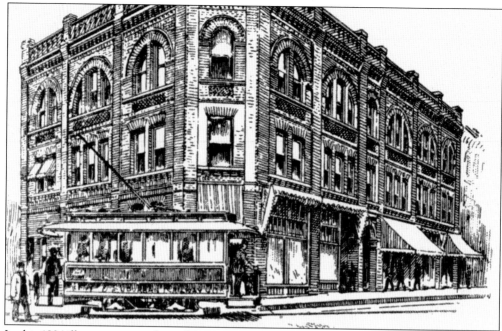

In this 1894 illustration, an inbound City & Suburban Railway single-truck Pullman trolley takes a jog on the tracks of the Lower Albina line between North Goldsmith and Delay Streets (now North Interstate at Russell). The Smithson Block, which was in the heart of the old Albina business district, survives today as part of the Widmer's Brewery.

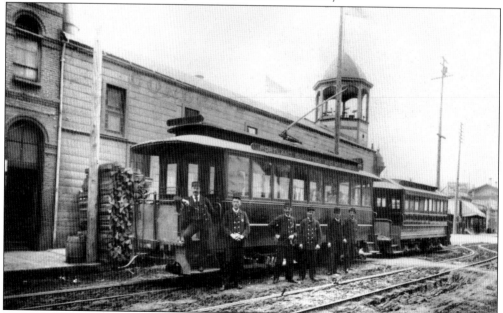

A Mount Tabor train, with Car No. 33 and Trailer No. 13, waits next to Cordray's Theater on Southeast Yamhill Street and Third Avenue, c. 1893. Although City & Suburban has taken over, Car No. 33 is still lettered for the Willamette Bridge Railway. This was the first double-truck trolley west of the Mississippi. It proved so successful at negotiating rough track and tight curves that C&S stopped buying four-wheeled cars. (Courtesy Oregon Historical Society, ORHi 28180.)

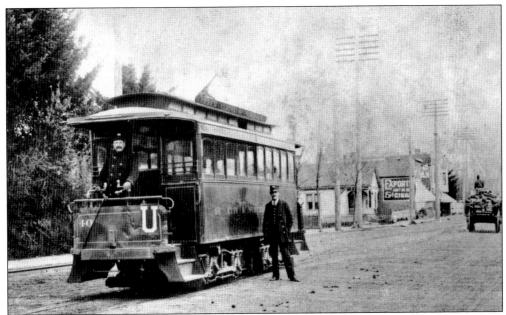

Longtime C&S employee Charles W. Love took many photographs, such as this one of Upper Albina Car No. 40 on Williams Avenue. The man next to the car is instructor Jack Workman, credited with operating the first trolley in Portland on November 17, 1889. This double-truck car, one of the C&S 1–46 Series, was rebuilt in the company shops by splicing together two horsecars.

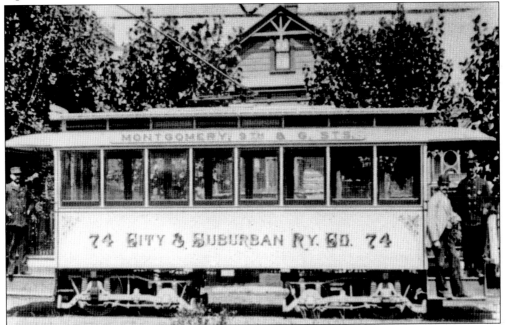

In 1892, the City & Suburban ordered the most splendid-looking trolleys the city had seen. The new eight-wheeled cars created a sensation when they arrived from the Pullman Palace Car Company, resplendent in white paint with mahogany-stained windows and gold trim. By 1901, these "White and Golds" would be enclosed and painted in darker colors like the rest of the fleet.

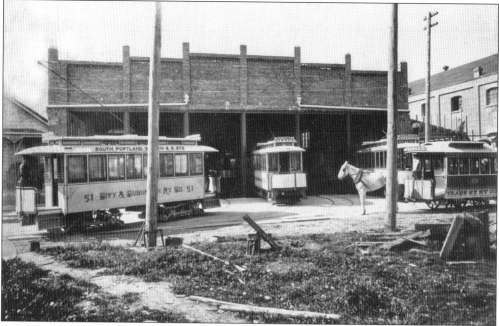

City & Suburban worked diligently to electrify all of its lines. When this photograph was taken in May 1892, Montgomery Street line horsecar No. 22 was pulling into the former Transcontinental Street Railway Savier carbarn for the last time. But first, it had to wait for several new white and gold Pullmans to roll by. (Courtesy Oregon Historical Society, ORHi 5685.)

This serious-looking group of City & Suburban platform men is posing in front of a white and gold Pullman at the Woodstock carbarn on Southeast Twenty-sixth near Powell in 1891, soon after the Waverly-Woodstock Electric Railway merged with C&S. The cigar-smoking man in front was probably an inspector or senior motorman.

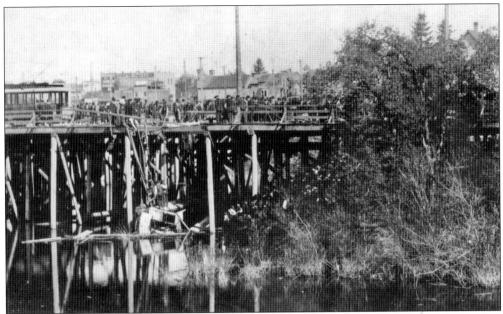

Four people died, and a number were injured, when westbound C&S Trolley No. 52 plunged through a trestle railing into the shallow water of Asylum Slough at 6:45 a.m. on April 28, 1897. The location was East Morrison Street between Seventh and Ninth Streets, an area long-since filled. The company discontinued service across Sullivan's Gulch, on nearby Grand Avenue, after the accident. (Courtesy Oregon Historical Society, ORHi 48873.)

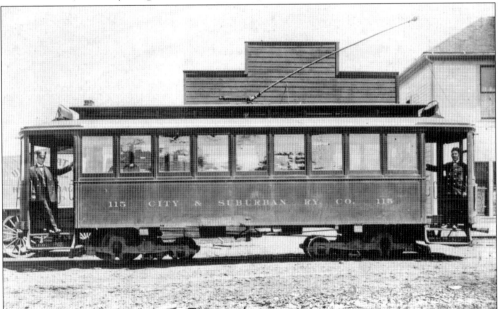

This broadside view of Car No. 115 was taken at Southwest Hamilton and Corbett Streets, the southern terminus of the North and South Portland line during the early 1900s. Car No. 115 belonged to the largest group of streetcars operated by the City & Suburban. In 1901, 47 of these standard cars were built in the company shops. The plain, high-riding cars survived into the 1930s, providing service on most lines.

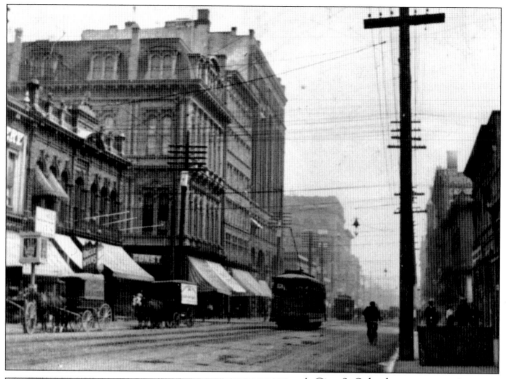

A City & Suburban open car is northbound on the S-North and South Portland line on Third Avenue, near the intersection with Washington Street, c. 1898. The S line replaced Metropolitan's line to Fulton Park. The 81–86 Series cars were called "Bald Faces" because their ends did not have windows. (Courtesy Mary A. Grant.)

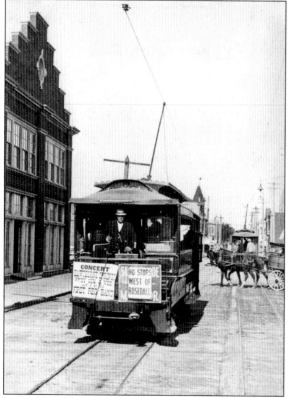

Two open-platform City & Suburban Railway Mount Tabor/Sunnyside cars pass on Southeast Morrison Street at Second Avenue at the beginning of the 20th century. The car in the foreground is an all-season California-style vehicle. The dashboard sign reading "No stops west of Rosedale" indicates it was running as a limited from the city limits near Thirty-ninth Street.

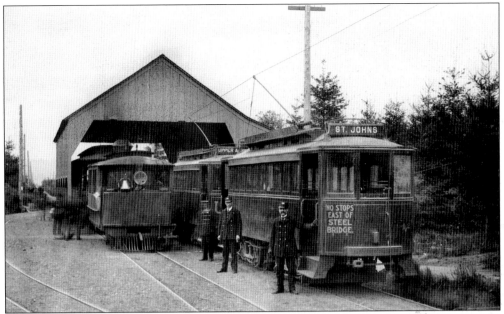

St. Johns and Upper Albina streetcars met St. Johns steam dummy trains at the Piedmont transfer station on North Killingsworth and Moore Streets during the C&S years. Passengers continued to transfer here even after the line was completely electrified in 1903, when larger narrow-gauge interurban cars made connections with the smaller city trolleys.

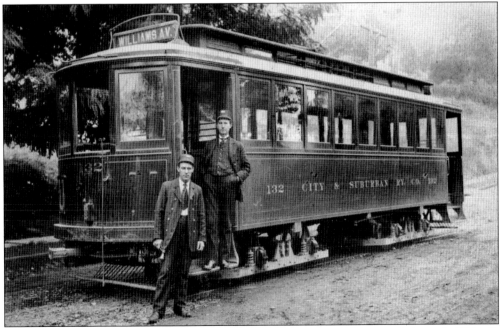

Car No. 132 and crew are pictured here on Williams Avenue in 1904, toward the end of City & Suburban's 12-year reign. By now, lighter colors, elaborate pin-stripping, and open platforms were a thing of the past. The large "U" on the dashboard harkens back to the original name of this line, Upper Albina. Two years previously, the company had stopped building these standards in favor of a new three-compartment design.

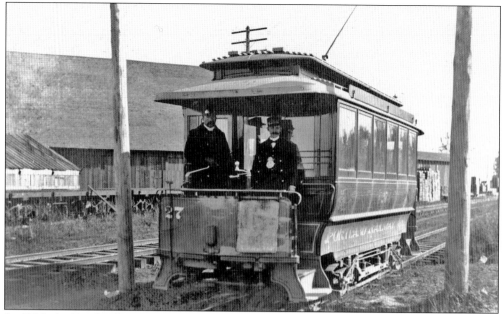

In 1896, the Portland Consolidated Street Railway was taken over by the Portland Railway, which soon put things back in good condition. Rolling stock was improved with innovations such as headlights (bracket on dash) and the first electric heaters. The photograph above was likely taken after the Sixteenth Street tracks were extended to Northwest Sherlock and Nicolai in 1899. Sidings and warehouses show a growing industrial area. (Courtesy Mark Moore.)

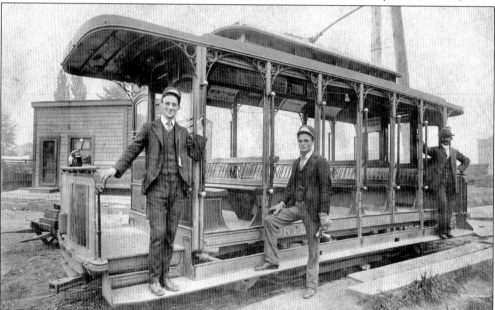

An open car of the first Portland Railway waits at the Sixteenth Street line terminus in the late 1890s. Cars No. 37 to No. 42 were described as the first open trolleys in town. They were convertibles when built for the Multnomah Street Railway, but adjusting them proved a nuisance, so they soon became permanent opens. The tobacco store in the background also served as a waiting room. (Courtesy Mark Moore.)

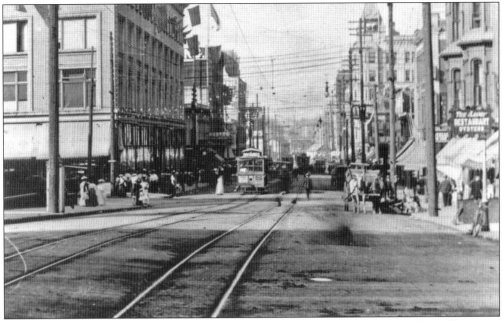

An electrified cable car of the first Portland Railway Company works it way south on Southwest Fifth Street at Yamhill Street around 1900. The Meier and Frank department store is on the left. All cable car routes, except for the steep incline up to Portland Heights, had been converted to electricity in 1896. In 1904, the last cable line would be discontinued.

In the early 1900s, hardworking shop and barn personnel break for a portrait at the Piedmont carbarn on North Killingsworth. The City & Suburban began planning this barn, the largest in the city, before their merger with Portland Railway. On the left is a 100-class C&S standard. Beside it is a yard motor, or "goat," No. 921, which was made from a Barnes Park Heights and Cornell Mountain passenger motor.

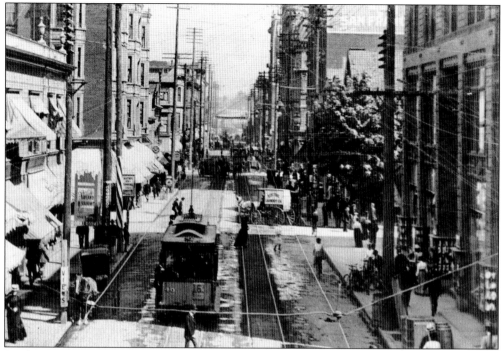

Portland Railway Car No. 40 has just passed another trolley on a Washington Street bustling with drays and buckboards. This photograph was taken around 1900 at the intersection of Sixth Avenue. The approaching streetcar is on the downtown leg of the Sixteenth Street run.

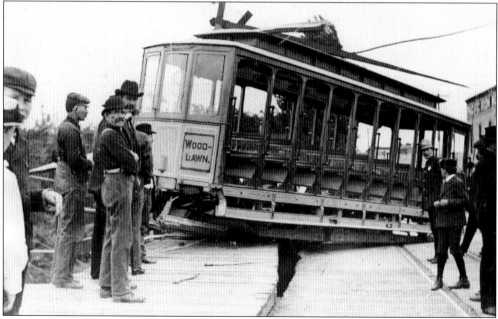

On June 21, 1903, Woodlawn Car No. 82 derailed at the east end of the Burnside Bridge. A couple of women suffered bruises. Things might have been much worse if a telephone pole had not kept the open trolley from going into the drink. Woodlawn was a branch of the Vancouver line, opened by the first Portland Railway in 1900.

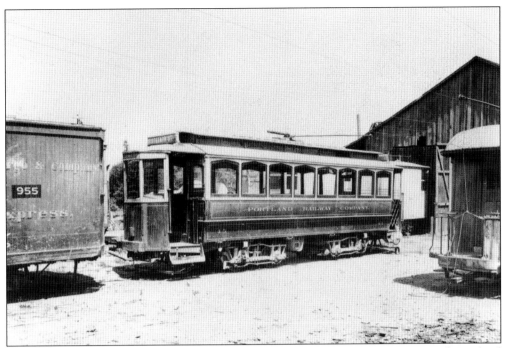

A Woodlawn barn scene features former Portland Railway No. 45 in the center, with Portland & Suburban Express box Motor No. 955 at left and a snow sweeper at right. Car No. 45 was a double-truck Brill originally used on the Washington Street line.

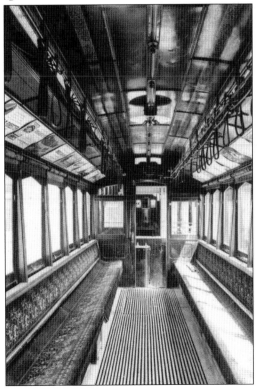

The interior of Car No. 45 shows carpeted, longitudinal bench seating. After these cars were transferred to the Vancouver line, they were called "Vancouver 40s," a nickname that stuck even after successor companies renumbered them in the 93–98 Series.

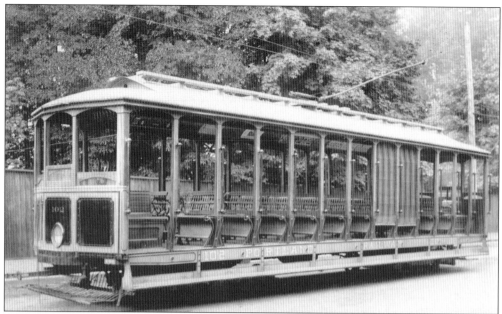

Portland Railway president Franklin Fuller influenced the design of center aisle open car No. 102, one of a series built in preparation for Lewis and Clark Exposition crowds. Originally kept at the Savier barns and used on the westside, they were later enclosed and transferred to the Piedmont barn for use on the Vancouver line. The Fuller brake levers caused some to think these were former cable cars. (Courtesy Mark Moore.)

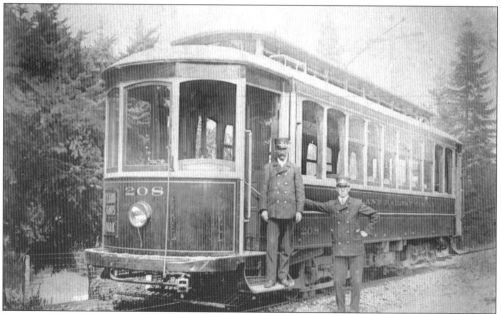

Portland Railway Car No. 208 was one of 10 acquired from J. G. Brill in 1904 to replace the last cable cars. These cars were equipped with four motors and magnetic brakes for hill service. Their semi-convertible design allowed windows to be stored in wall and ceiling pockets. Later renumbered in the 500s, they came to be known as "Council Crests." The dash sign reads, "Portland Heights/City Park."

## *Three*

# THE FIRST INTERURBAN
## 1891–1905

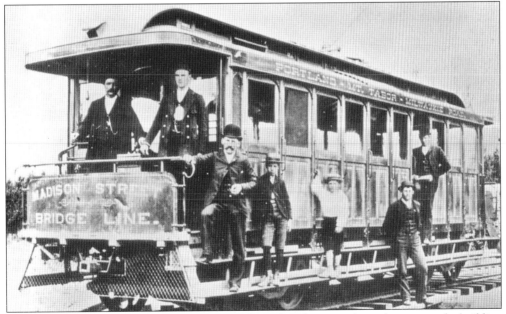

Like the Willamette Bridge Railway, the East Side Railway began with emphasis upon the building of a bridge connecting Portland and East Portland. Hence the dash sign for the Madison Street Bridge Line. When this photograph of the *Alva* was taken in 1891, the interurban line to Oregon City had not yet been built. Tracks only extended some four miles south via Milwaukie Road to the community of Brooklyn.

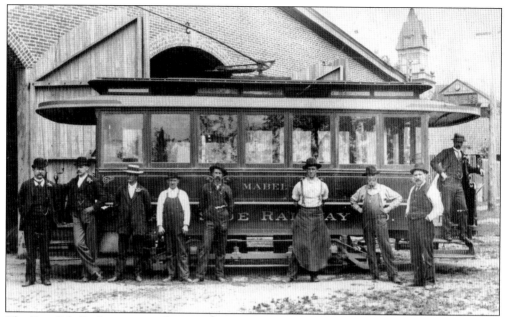

The East Side Railway assigned its cars women's names instead of numbers. *Mabel*, seen here at the new Milwaukie barn around 1892, was a single-truck Pullman originally intended for use on Hawthorne Avenue. That steam motor line was not electrified until 1893, so the car was shifted to the Oregon City line. Within a few years, it would be spliced with twin *Nora* to create Oregon Water Power Interurban No. 1045.

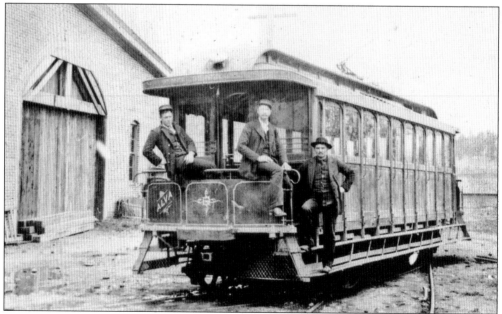

*Alva*, one of the East Side Railway's original 10 cars, was a Low's convertible, locally built by Vulcan Manufacturing in 1891. It was very similar in appearance to convertibles built for the Metropolitan Railway, which was then owned by the same interests. The Milwaukie barns in the background, which opened in December 1892 at what are now Jackson and Harrison Streets, are still under construction in this photograph.

# EAST SIDE RAILWAY COMPANY.

ONE OF THE

## LONGEST ELECTRIC RAILWAYS IN THE WORLD

FROM AND THROUGH

### PORTLAND, SELLWOOD, MILWAUKIE, OAK GROVE, GLADSTONE AND OREGON CITY

TO THE

## FALLS OF THE WILLAMETTE

The Route Covered by the Lines of this Company offers Excellent Inducements for

### EXCURSIONS, PICNICS AND SPECIAL OR OUTING PARTIES

For which Special Arrangements will be made.

It is a charming ride, with comfortable cars and picturesque scenery. A ride to the Falls of the Willamette or intermediate points, will prove not only restful, but far more beneficial to health than all the medicines. TRY IT !

## ..TIME TABLE..

### OREGON CITY DIVISION.

45 MINUTE SCHEDULE.

| LEAVE PORTLAND, FIRST AND COUCH STREETS. | | LEAVE OREGON CITY. | |
|---|---|---|---|
| 7:00 A. M. | 3:15 P. M. | 7:05 A. M. | 4:50 P. M. |
| 7:45 | 4:00 | 7:50 | 5:35 |
| 8:30 | 4:45 | 8:35 | 6:20 |
| 9:15 | 5:30 | 9:20 | 7:05 |
| 10:00 | 6:15 | 10:05 | 7:50 |
| 10:45 | 7:00 | 10:50 | 8:20 only to |
| 11:30 | 7:45 | 11:35 | Milwaukie |
| | 8:30 only to | | 9:15 |
| 12:15 P. M. | Milwaukie | 12:20 P. M. | 10:30 |
| 1:00 | 9:15 | 1:05 | 11:45 only to |
| 1:45 | 10:30 | 1:50 | Milwaukie |
| 2:30 | 11:40 | 2:35 | |
| | | 3:20 | 12:50 only to |
| | | 4:05 | Milwaukie |

### FOR MOUNT TABOR.

Leave Portland (Couch Street) every 30 minutes from 6:15 A. M. to 11:15 P. M. Returning from Mount Tabor, leave there on same time.

### FOR MOUNT SCOTT.

Leave Portland (Couch Street) every hour from 6:45 A. M. to 6:45 P. M., then 11:15 P. M. Leave Mount Scott every hour from 5:55 A. M. to 6:55 P. M., then 10:30 P. M.

Passengers for East Portland, Brooklyn, Sellwood, Milwaukie, Oak Grove, Gradstone, Oregon City, take OREGON CITY CARS.

Passengers for East Portland, Sunnyside, Glencoe Park, Tabasco, Mount Tabor, and all points contiguous to Hawthorne Avenue, take MOUNT TABOR CARS.

Passengers for Chicago, Tremont and other points between Hawthorne Avenue and Mount Scott, take MOUNT SCOTT CARS.

Subject to change without notice.

This 1895 East Side Railway timetable shows 45-minute service on the nation's first true interurban. Although electric railways connecting towns had previously been built, the Oregon City line was the first one designed for passengers, baggage, mail, and freight. It was also the first to regularly interchange freight cars with steam railroads and the first to use electricity transmitted over long distances from a hydroelectric dam.

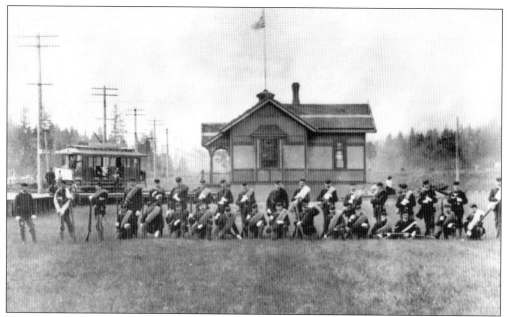

Troops of the Clackamas County National Guard mustered in front of Gladstone station in 1898 during the Spanish-American War. In the background, an East Side Railway convertible is turning onto the spur leading to the Chautauqua grounds one-half mile to the east. One car was assigned to this branch line and kept in a barn near the park. This service, which operated from Oregon City, was discontinued in 1901.

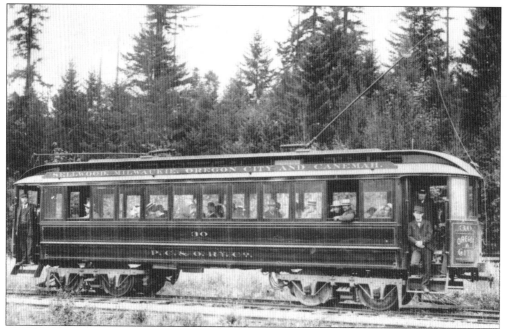

In 1901, after seven years in receivership, the East Side Railway was reorganized as the Portland City & Oregon. New management launched an aggressive car-building campaign at the Milwaukie shops, enclosing and remodeling former East Side rolling stock. The project began with Car No. 30, which was also the first Oregon City interurban car to be given a number rather than a name.

At 6:45 a.m. on a dark, foggy November 1, 1893, the East Side Railway car *Inez* slid on icy rails and ran through an open draw on the Madison Street Bridge, plunging 43 feet into the Willamette River. As depicted in this contemporary newspaper illustration, not all of the 20 passengers and crew escaped. Seven died in the worst accident in Portland streetcar history.

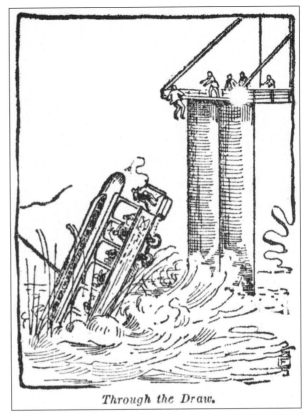

*Through the Draw.*

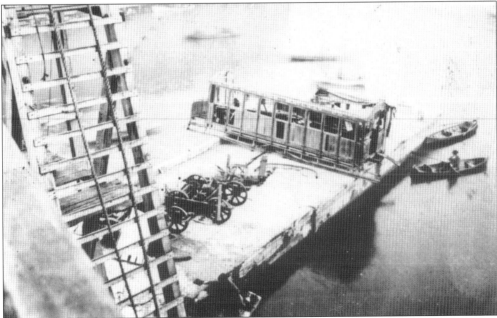

The *Inez* was pulled from the river within 24 hours but was too badly damaged for rebuilding. The ensuing damage suits also proved too much for the fledgling railway, which went into receivership.

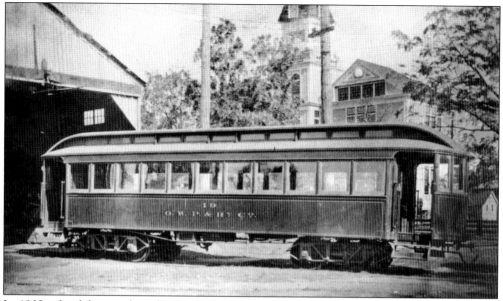

In 1902, after labor strife and several wrecks, the Oregon Water Power & Railway Company (OWP) replaced the Portland City & Oregon and began raising money for new interurban lines. Tracks were laid eastward to Gresham before electric power was available, so trailers such as Holman-built No. 19 were initially pulled behind steam locomotives. At left is a newly expanded Milwaukie carbarn. The public school is in the background.

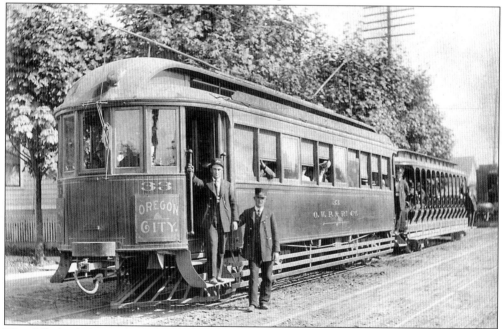

This fully loaded train, with OWP No. 33 and an open trailer, is on a residential section of the Oregon City line. Car No. 33 was part of a four-car (32–35) order from the Holman Company of San Francisco in 1901. These were slightly shorter than their locally built sisters and bore the distinctive five-windowed Holman ends. The work vehicle at the far right appears to be OWP line Car No. 109. (Courtesy Mark Moore.)

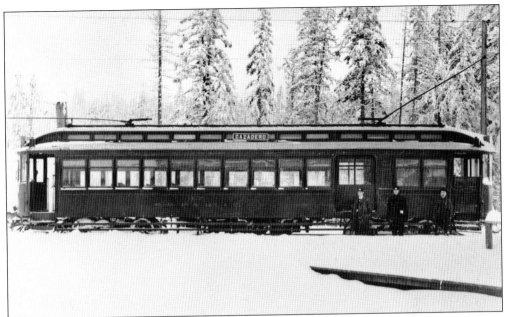

In an unusual shot taken between 1903 and 1905, OWP Car No. 47 has been fighting its way through snow on the new Estacada line. There are not many pictures of this rebuilt Holman combine because it wrecked at Hogan station near Gresham on May 11, 1911. Notice the freight door, side destination sign, and side slats over the running gear.

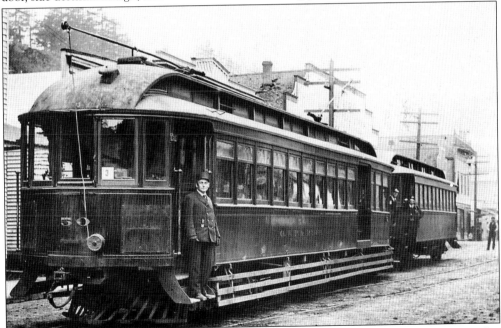

An OWP combine No. 50 and trailer awaits passengers in Oregon City in the early 1900s. Car No. 49 and No. 50 were original equipment ordered from the Holman Car Company of San Francisco for the new line to Estacada and Cazadero (the Springwater Division) in 1903. Car No. 50 was later modified so that its freight section (marked by the large side door) became a smoking compartment.

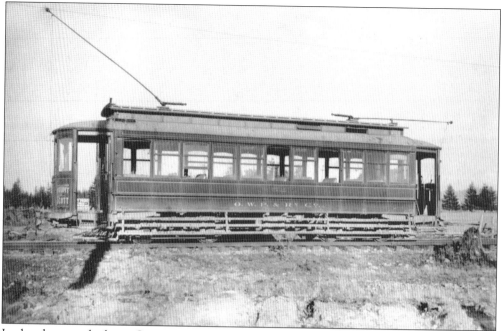

In the photograph above, Oregon Water Power & Railway Car No. 52 is ready to return to town after reaching the undeveloped area at the end of the Mount Scott line. This route, originally served by Portland, Chicago & Mount Scott steam motors, was briefly cancelled by the Portland City & Oregon because management was focused on building a new interurban line to Estacada.

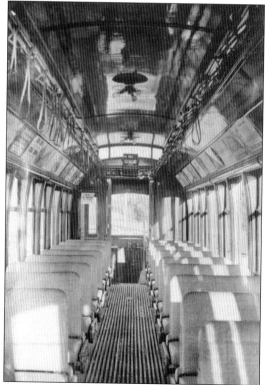

This sunny interior view of OWP Car No. 52 or No. 53 reveals a suburban, rather than interurban, layout. In fact, these cars were Brill semi-convertibles, very similar in appearance to the narrow-gauge Council Crest cars ordered at approximately the same time. Fittings included Hale and Kilburn rattan walkover seats, standee straps, and an Ohmer fare register.

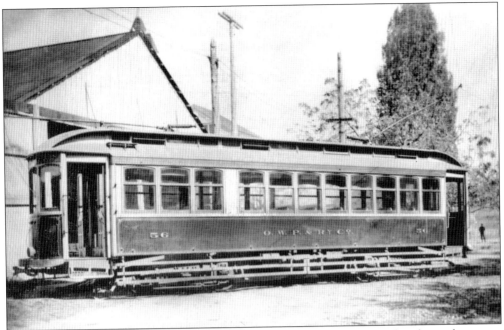

In 1904, OWP No. 56, pictured here in front of a new extension to the Milwaukie carbarn, was ordered from the J. G. Brill Company of Philadelphia. Unlike Brills No. 52 and No. 53, this car was more typical of interurban design, with arched railroad roof and two compartments. In the long run, however, it would be reduced to city-line status like the others.

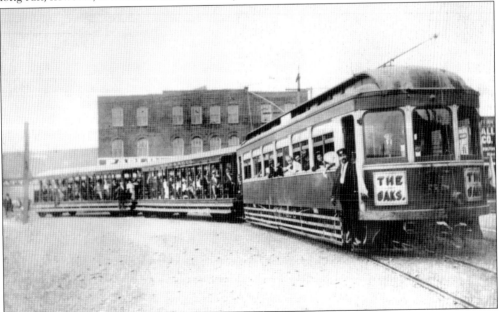

Oregon Water Power & Railway No. 58 is loaded with pleasure seekers as it rounds the turn from Southeast Hawthorne onto the private right-of-way, bound for Oaks Park. The beautiful Niles interurban, with its graceful lines and arched sightseeing windows, ended its years as a line maintenance car. At the close of operations, this car (renumbered to 1058) was preserved by a private collector.

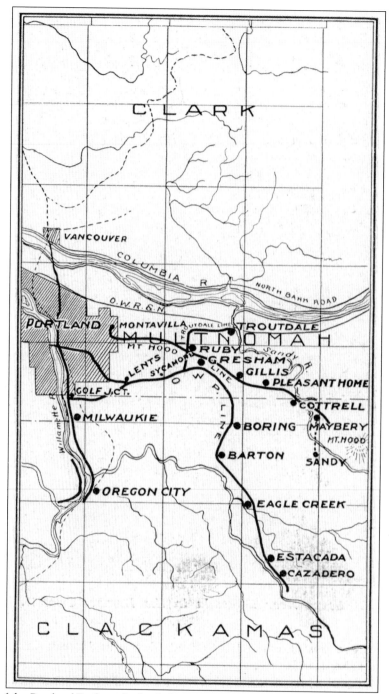

This map of the Portland Railway, Light & Power Company interurban lines appeared in a 1912 guidebook entitled *How to See Portland by Trolley*. It shows the narrow-gauge line to Vancouver, Washington, (electrified in 1893) and standard-gauge lines to Oregon City (1893), Cazadero (1901), Gresham (1903), and Troutdale (1906), as well as the Mount Hood Railway line, which was completed to Bull Run in 1911 and electrified in 1914. Today the MAX eastside line operates over the Mount Hood right-of-way.

# *Four*

# MILLIONS FOR
# STREET RAILWAYS
## 1904–1906

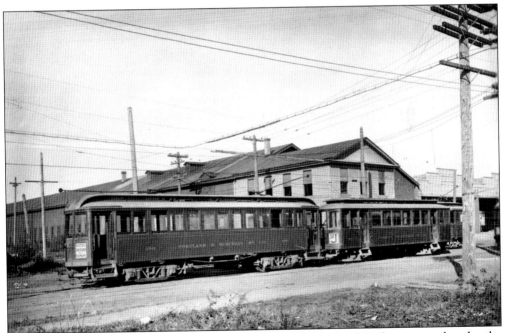

In September 1904, rivals City & Suburban Railway and Portland Railway merged under the short-lived name of the Portland & Suburban Railway. One month later, after it was discovered that a railway express firm was already using that name, the new company was renamed Portland Consolidated Railway. Car No. 196, seen here at the Piedmont barn with Portland Consolidated No. 351, was one of the few cars re-lettered for the Portland & Suburban.

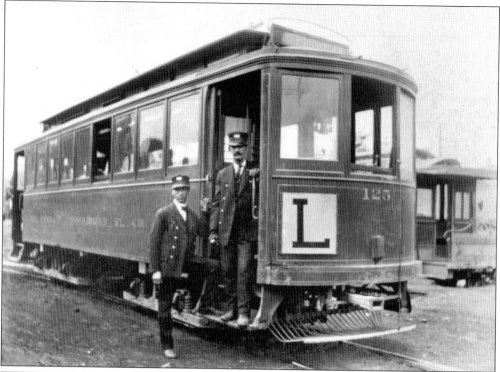

Still working the Mississippi Avenue line in North Portland, C&S standard Car No. 125 had become part of the Portland Consolidated Railway by the time this photograph was taken. The location is unknown, but the cable car on the right never operated on the east side of the river. In the spring of 1904, the last cable car ran to Portland Heights in the West Hills.

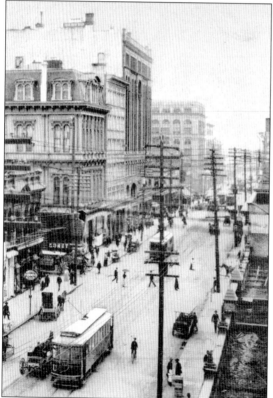

Third Avenue is bustling with at least nine streetcars on this postcard mailed in 1907. The trolley closest to the camera is former C&S standard Car No. 110. The destination signs for Montgomery Avenue (roof roll sign) and Upper Albina (dash sign) indicate this is an Albina-Montgomery car. The only building in this photograph remaining today is the Dekum Building in the center background.

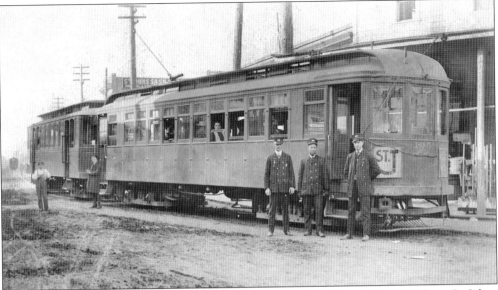

Motor No. 195 and a 350-Series Fuller trailer make up a Portland Consolidated Railway, St. Johns train in this c. 1906 view in downtown St. Johns. A two-car train like this could carry more passengers with fewer crewmembers (one less motorman). Note how the trolley rope has been lashed down in the absence of a trolley retriever. (Courtesy Mark Moore.)

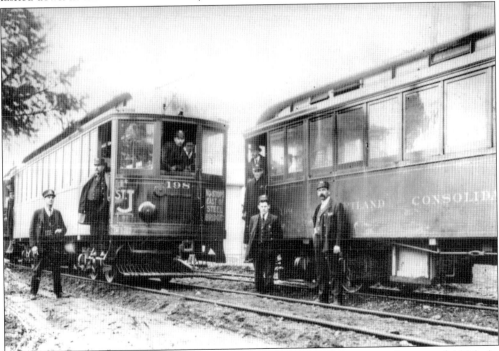

Two Portland Consolidated, St. Johns trains meet at the Piedmont transfer around 1906. As indicated by the dash sign, these narrow-gauge interurbans made no stops from the Steel Bridge to Piedmont because city streets did not easily accommodate two or three car trains. A new side panel encloses the former California-style front on No. 199. Note the rotary gong on the front of No. 198.

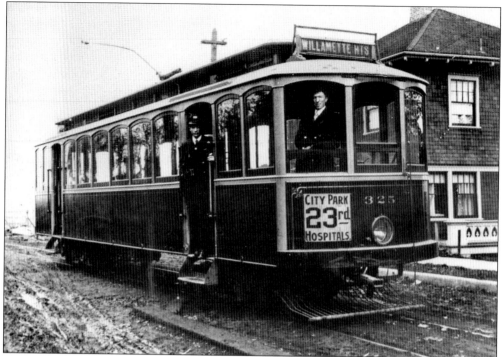

Around 1905, Willamette Heights No. 325 is near the muddy end of the line on Northwest Thurman Street. The line was electrified by the Multnomah Street Railway Company in September 1891. The Fuller-style trolley was constructed in 1903 in the Portland Railway shops at Southwest Twenty-third Avenue and Burnside. Note the arched windows and Portland Railway safety fender.

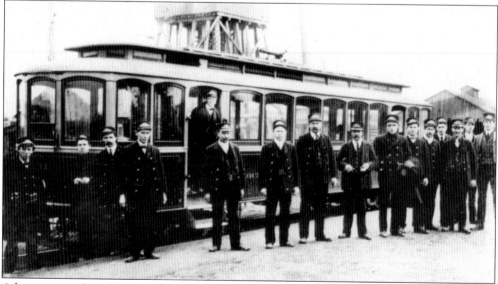

A large group of conductors and motormen has gathered for a portrait in front of Fuller standard Car No. 331. They are at the former Portland & Vancouver Railway Woodlawn barn near Northeast Eighth and Dekum in North Portland. A large water tower remains, but the steam dummy locomotives had been retired in 1893.

In 1905, Portland Consolidated Railway Fuller Car No. 339 is waiting for passengers at the end of the Broadway line. This oldest of Broadway line photographs was probably taken at the original end of the line at Northeast Twenty-first and Halsey, a quiet, residential area in the years before the Broadway Bridge opened in 1913. (Courtesy Mark Moore.)

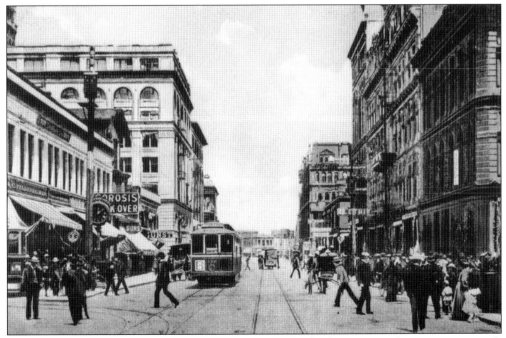

This view of Broadway line Car No. 310 on Southwest Third Avenue at the intersection with Washington Street is from an early-20th-century postcard. No automobiles are yet in evidence. The old chamber of commerce building in the left background was razed in 1934.

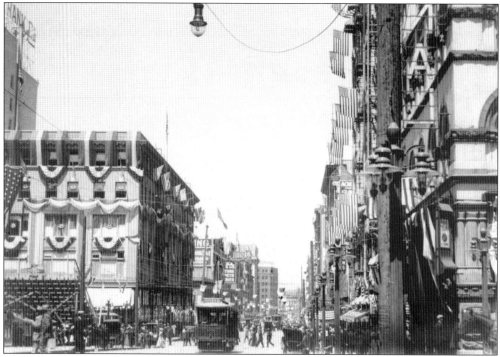

In this early 1900s photograph, Sixteenth Street line "Bald Face" open Car No. 205 is traveling north on Southwest Fifth Avenue at Morrison Street. A grandstand has been erected next to the Pioneer Courthouse, and the Meier and Frank and Goodenough Buildings are festooned in bunting, probably for the Rose Festival. The car was one of a series built by the City & Suburban Railway in readiness for the Lewis and Clark Exposition.

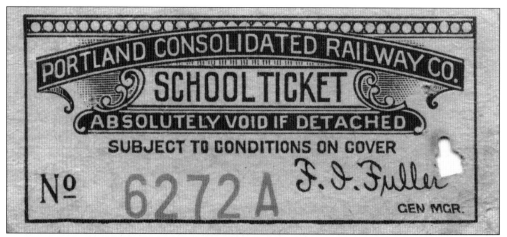

Portland's street railway companies sold prepaid ticket booklets of various types. This student ticket from the Portland Consolidated Railway dates from 1904 to 1905. It is signed by general manager Franklin Fuller, who would become company president in 1913.

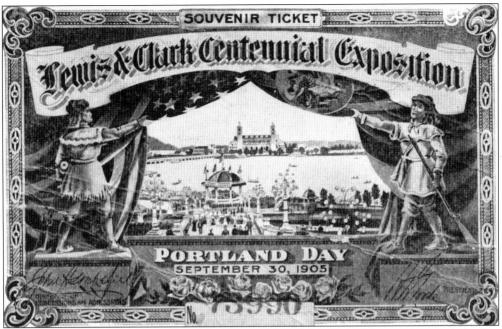

On September 30, 1905, this souvenir ticket to the Lewis and Clark Exposition was issued to local residents on Portland Day. The exposition remains the largest celebration ever held in Portland. The Portland Consolidated Railway Company carried a million passengers a week to the exposition grounds at Northwest Twenty-sixth and Upshur that summer.

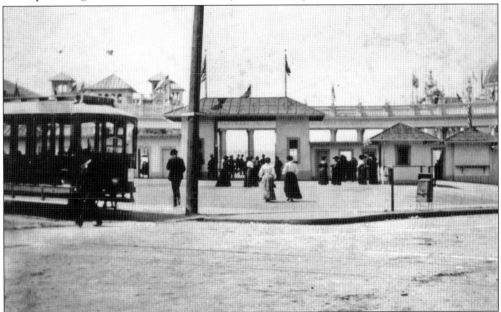

A Fuller open car on the Sixteenth Street line awaits passengers during the summer of 1905 at the gates to the Lewis and Clark Centennial Exposition, located at the two-track loop on Northwest Upshur, which ran between Twenty-fifth and Twenty-seventh Streets. The Portland Consolidated Railway rerouted the Morrison, Sixteenth, Twenty-third, and Willamette Heights lines to serve the fair. A new car rolled up to the gates every 30 seconds.

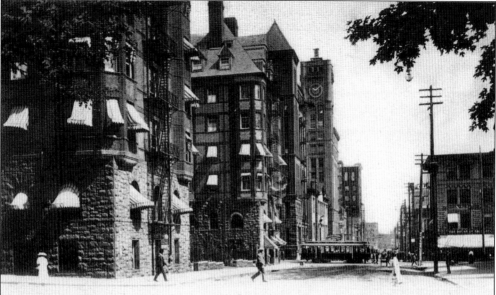

Sixth St., showing Portland Hotel, Marquam, Oregonian and Wells Fargo Buildings, Portland, Ore.

This *c.* 1908 postcard shows a Morrison line, Toronto-style trolley on Morrison Street at Sixth Avenue, adjacent to the Portland Hotel. In 1951, this famous hotel was razed for a parking lot. Streetcars of the type pictured here were known as "Torontos" because builder City & Suburban Railway patterned them after a Canadian car.

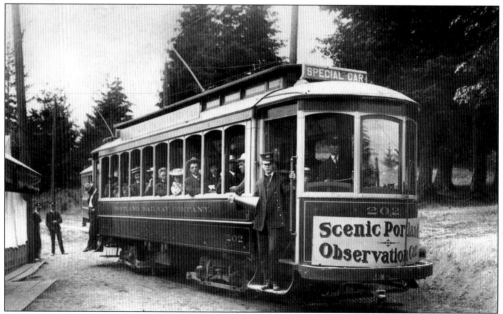

Car No. 202 has been pressed into service as a sightseeing car. The location is unknown, but it is likely on Portland Heights. For several months after these Brill streetcars arrived, they were the only magnetic brake-equipped trolleys ready for hilly routes. The fully loaded car is still lettered for the Portland Railway Company, but the year is thought to be 1905, when fair crowds created a demand for observation cars.

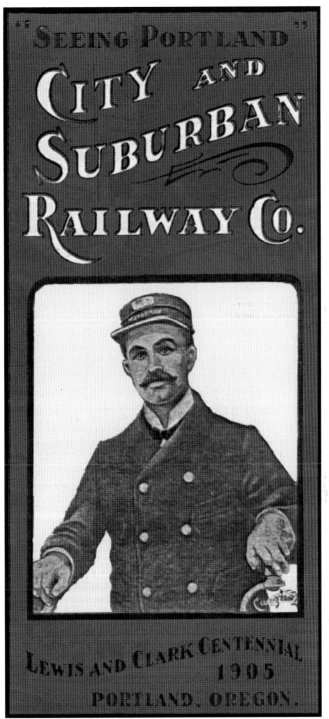

"SEEING PORTLAND"

CITY AND SUBURBAN RAILWAY CO.

LEWIS AND CLARK CENTENNIAL 1905 PORTLAND, OREGON.

This brochure for City & Suburban Railway tours promoted the upcoming Lewis and Clark Exposition. Both the Portland Railway and the City & Suburban Railway offered excursions of downtown, residential districts, and the hills. The City & Suburban built the open observation Car No. 300 for this service.

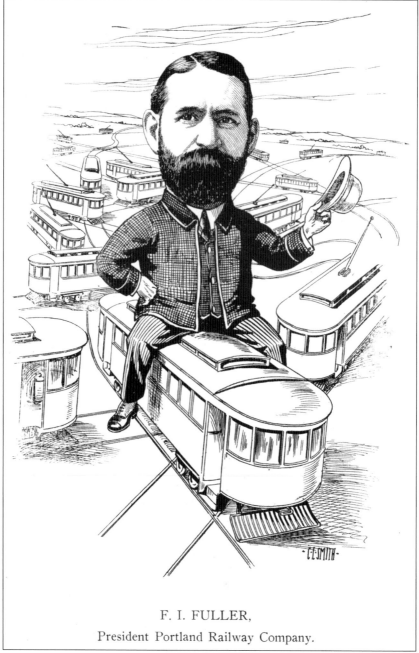

**F. I. FULLER,**
President Portland Railway Company.

This 1905 caricature shows Portland Railway president Franklin I. Fuller astride a Toronto-style streetcar. Ironically these trolleys inherited from rival City & Suburban Railway were their response to Fuller-influenced designs. Fuller, an attorney by training, was one of the most influential businessmen in the industry. He began his transit career as manager of Portland Cable Railway in 1892 and went on to be general manager of Portland Consolidated Railway (1904), president of Portland Railway (1905), vice president of Portland Railway, Light & Power (1906), and president of Portland Electric Power (1924). He continued to act as traction company legal counsel into his 80s, although he had been semiretired since 1940.

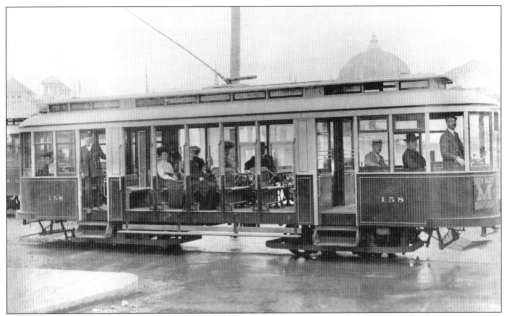

In 1902, City & Suburban designed its own three-compartment trolleys, known as "Torontos" after a Canadian car rebuilt during the same period. This rare view of Morrison line Car No. 158 at the exposition shows one of only two cars to operate with the center section open. All Torontos were equipped with removable sides, but none were run this way after the fair. (Courtesy Mark Moore.)

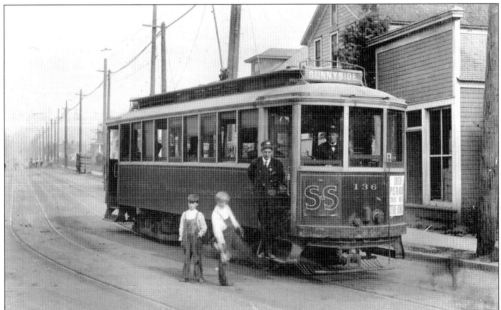

Sunnyside tripper No. 136 has changed ends and is ready to head back west at Southeast Thirty-ninth and Belmont Streets on a warm 1906 day. As can be seen, carline terminals were meccas for small boys. With the arrival of the second Portland Railway Company, Portland's streetcar system came under the control of Philadelphia and New York interests. Note the headlight mount and multiple-unit connector.

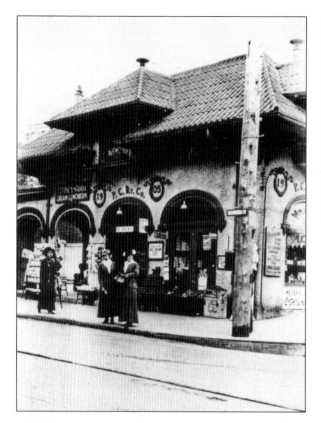

Employees of the Portland Consolidated Railway Company enjoyed the luxury of a soda fountain right across the street from the carbarn. Consolidated's station, located on the southwest corner of Twenty-third Avenue and Washington (now Burnside) Street, also housed the Keystone Ice Cream Parlor. Trolleys bound for Portland Heights, City Park (now Washington Park), and the Lewis and Clark fair all went by this new building.

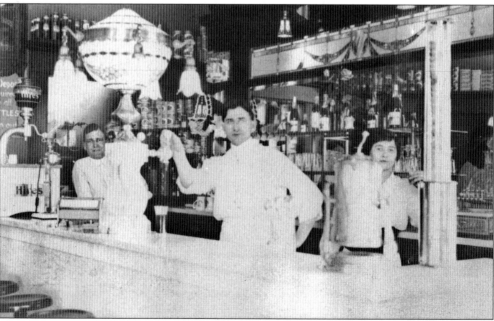

A wealth of beverage and ice cream choices were available at the Keystone Ice Cream Parlor, as seen in this view of the ornate interior. To keep things all in the family, manager George Foss was a retired motorman.

*Five*

# AFTER THE
# FINAL MERGER
## 1906–1924

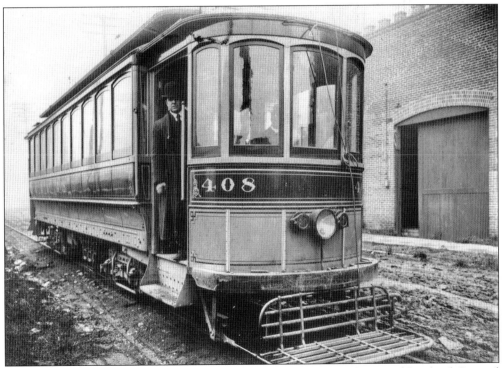

On June 28, 1906, Portland Railway, Oregon Water Power & Railway, and Portland General Electric (the electric utility) merged to become Portland Railway, Light & Power (PRL&P). All Portland street and interurban railways, including 375 cars and nearly 200 miles of track, were now consolidated. The shiny, new trolley above was part of the first car order placed by the new company. It was built in 1907 by the American Car Company of St. Louis. Perhaps the officious-looking man in the derby is inspecting things for the Philadelphia and New York stockholders. (Courtesy Oregon Historical Society, ORHi 48371.)

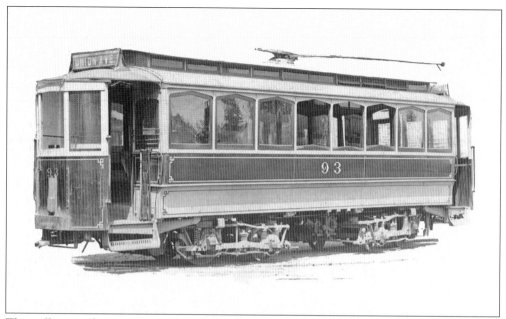

This yellowing photograph, stuck to the wall with a thumbtack, was the oldest in the records maintained by Earl B. Richardson, Portland Traction Superintendent of Equipment in the 1950s. Brill-built Car No. 93 was among the hodgepodge of old rolling stock inherited by PRL&P. As Car No. 43, it helped inaugurate trolley service on the Vancouver line in 1893. By 1917, the veteran trolley had been taken out of service.

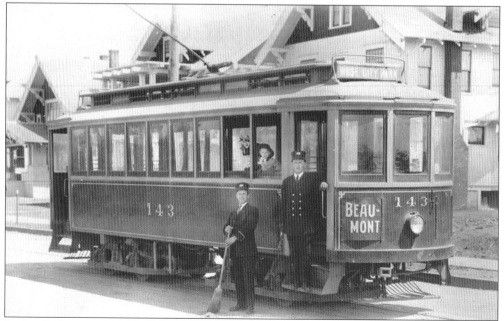

In this 1912 scene, the crew is readying Car No. 143 at the end of the Beaumont line on Northeast Forty-first at Klickitat, as a young rider looks on. The conductor has turned the pole and swept out the car, and the motorman (still gripping the controller handle) has changed ends. Beaumont was added to the East Ankeny line in 1911, a year before that line became Rose City Park.

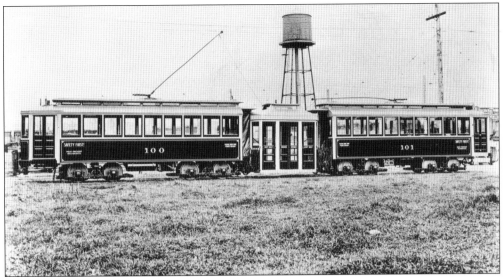

Car No. 100-101 was an experimental articulated car, similar in concept to Boston's "two rooms and a bath" design, but using double-truck cars. PRL&P built the car in 1913 using two former City & Suburban cars. A conductor's cab, with entry and exit doors, was hung between the two cars, each of which had one platform removed. This photograph of the completed car was taken at the new Center Street shops.

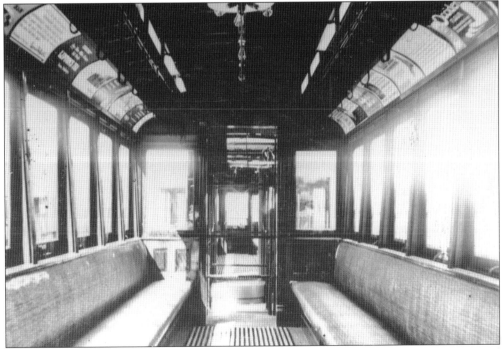

An interior view of twin Car 100-101 gives some idea of its 73-foot length. Staffing consisted of two conductors and a motorman, as in two-car trains. The capacity, with standees, was 102. Although this car accommodated more passengers with less crew, its performance suffered from slow boarding and acceleration. No additional vehicles of this type were built. (Courtesy Mark Moore.)

By 1909, Car No. 138, still wearing the Portland Railway name, had been leased to Kenton Traction Company. PRL&P considered former City & Suburban standard cars like this, with a passenger capacity 60 percent less than the newer vehicles, outdated. From 1909 to 1928, the privately run Kenton line linked the company town of Kenton with the Union Stockyards in north Portland. Note the different style uniform hats. (Courtesy Mark Moore.)

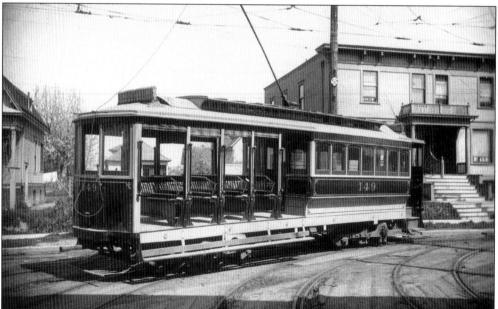

PRL&P No. 149 is pulling out of the Ankeny Street carbarn on Northeast Couch east of Twenty-eighth Avenue around 1908. A very interesting car, No. 149 was one of just three California-style (meaning half-open and half-closed) cars in the Portland system. It was fashioned from two horsecar bodies by the Hand Manufacturing Company in 1899. This series was not popular with the company and not used after 1917.

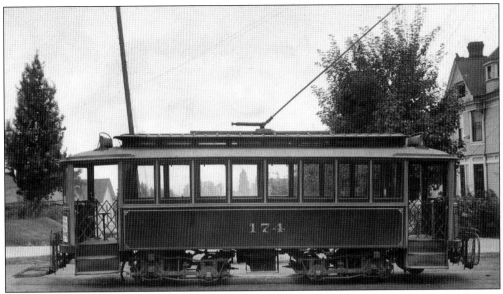

This 1910s photograph of Thirteenth Street line Car No. 174 is thought to have been taken on Southwest Montgomery Street. Car No. 174 was one of the City & Suburban Railway's "White and Gold Pullmans" built in 1891. These cars were the best looking in their day, but most did not survive as long as other C&S veterans. By 1919, Car No. 174 was out of service. Note the Maximum Traction trucks and platform gates.

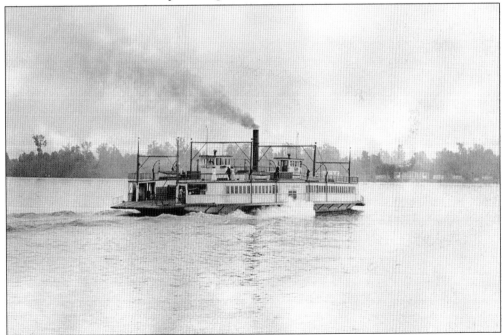

Before the building of the Interstate Bridge across the Columbia River, those wanting to travel to Vancouver, Washington, caught a ferry from the Portland and Vancouver landing on Hayden Island. The wooden side-wheeler, *City of Vancouver*, was the second of two vessels owned and operated by Portland street railway interests. Operations ceased with the building of the bridge in 1917.

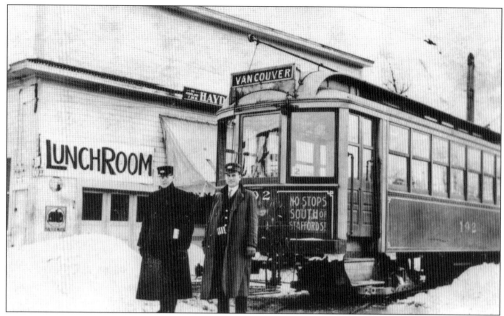

Maybe it did snow more in those days. The bundled-up crew of Vancouver No. 192 certainly looks ready to step into the station/lunch room at Hayden Island for a hot "cuppa" on this cold morning in the 1910s. "No stops south of Stafford St." meant the car did not stop for passengers as it proceeded along Union Avenue through North Portland.

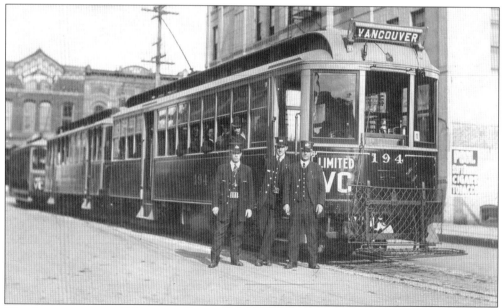

The three-man crew of Vancouver Train No. 1 poses at Third Avenue and Main in Vancouver around 1913 with narrow-gauge Interurban No. 194 and a 350-Series Fuller trailer. A 241-class open car has pulled up close behind. It is not part of the same train. Three-car trains were rarely used on the VC line. (Courtesy Mark Moore.)

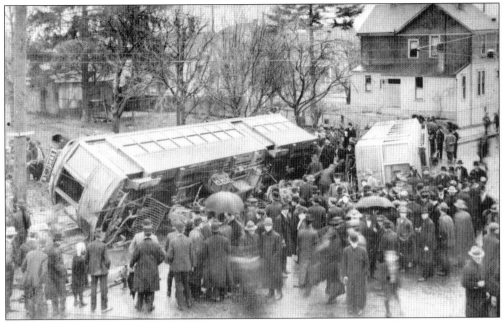

The January 19, 1909, headlines trumpeting, "Cars Driven at Terrific Speed," describe this wreck on the St. Johns line. An airbrake failure caused Motor No. 601 to leave the rails on the curve at North Williams Avenue and Cherry Street, pulling Trailer No. 353 with it. Their speed was estimated to have been 25 miles per hour. There were no fatalities, but 18 of the 66 passengers were injured when the cars overturned.

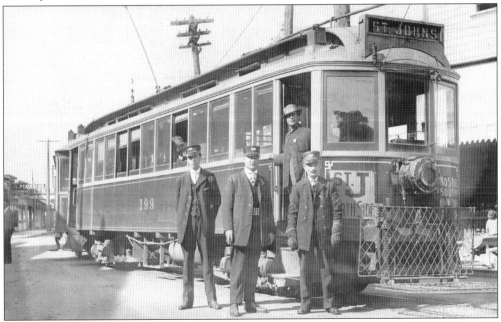

St. Johns Train No. 5, with Motor No. 199 and Trailer No. 275, boards passengers at North Philadelphia and Jersey Streets on a bright afternoon in the teens. The crew included motorman Albert H. Stein (in gloves), conductor Merrill A. Lean, and trailer conductor John H. Neff. Note the removable interurban-type carbon arc headlight.

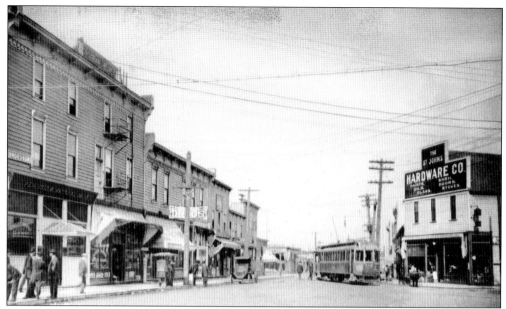

All aboard! A two-car train is ready to depart the St. Johns terminus at North Jersey and Philadelphia Streets on a quiet day in the 1910s. Things were very different in August 1916 when four boys were arrested for starting an apple-throwing melee on a St. Johns car. Apparently they had raided an orchard for "ammunition" before getting on. Passengers and crew were unable to stop the riot involving 17 boys.

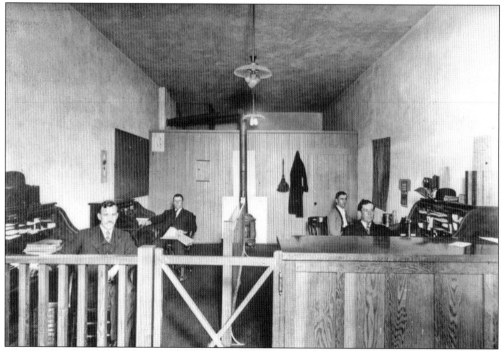

The Portland Railway, Light & Power Company office at North Jersey and Chicago Streets in St. Johns was sparsely decorated, but at least there were electric lights and heat from a potbellied stove. Note the rolltop desks, paneled ticket counter, and lack of female employees.

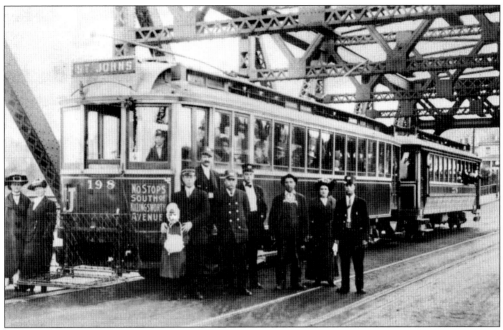

Look at those hats! The first St. Johns train over the new Broadway Bridge stopped in mid-span to have the moment recorded for posterity. Before this bridge was erected in 1913, the St. Johns line used the old Steel Bridge. Train No. 4 is headed by Motor No. 198, with Trailer No. 278 following. Both were St. Johns–class cars.

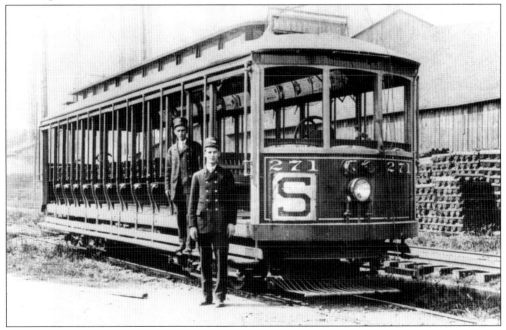

Trolley No. 271 rests next to a stack of cordwood at the end of the North and South Portland line at Northwest Twenty-first and Sherlock, c. 1910. Car No. 271 was the only Council Crest open not to receive magnetic brakes in 1912. On the other hand, it was equipped for multiple-unit operation (connections on dash). In 1918, the entire 260–273 Series was rebuilt as closed cars.

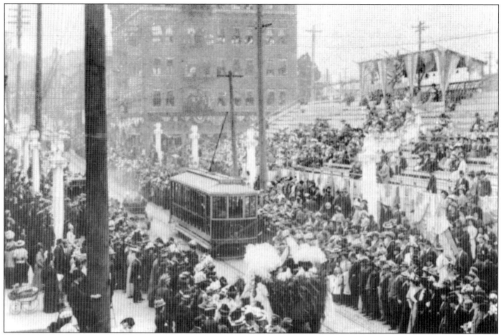

A sizable crowd has gathered for an early Rose Festival parade at Southwest Morrison Street between Fifth Street and Sixth Avenue, and a grandstand has been erected on the north side of the Pioneer Post Office. The Corbett Building towers in the background as Sunnyside summer Car No. 225 picks its way eastward through the throng.

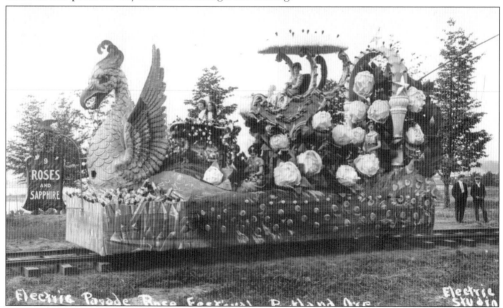

During the 1910s, the Rose Festival parade was known as the Electric Parade because floats were mounted on old streetcar trucks. They were self powered and illuminated with hundreds of variously colored electric lights. This photograph was taken at the former Lewis and Clark Exposition grounds, where the floats were stored during the first years of the Rose Festival. The first parade followed close on the heels of the exposition.

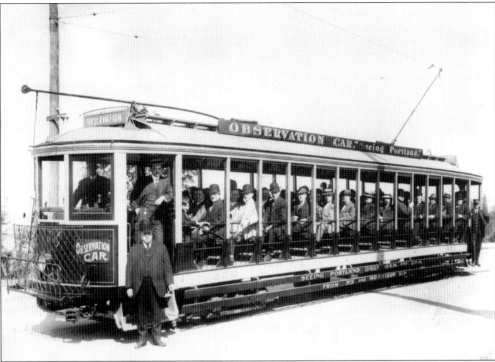

Pictured here in 1912 is Car No. 300, "Seeing Portland," with members of the Transportation Club. The observation car left twice daily for two-and-a-half-hour sightseeing trips, including 15-minute lecture stops at the exposition grounds and Council Crest. On this tour, the group was escorted by PRL&P traffic manager Frank D. Hunt, who is standing next to the trolley.

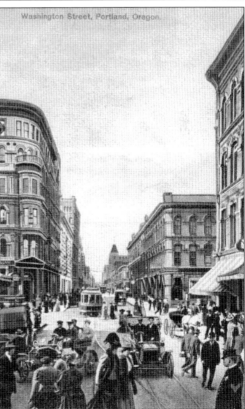

In 1898, the first automobile appeared in Portland at a time when they were still expensive toys for enthusiasts. But by the time this postcard was printed about 1907, the cars seen cutting around trolleys on Washington Street were a harbinger of rush hours to come.

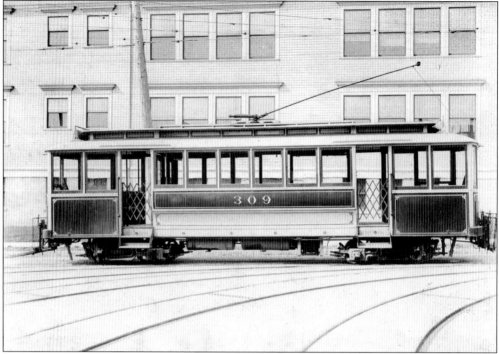

Fuller Car No. 309 was built by extending the body of an old Multnomah Street Railway single-truck Pullman, the details of which can clearly be seen in this *c.* 1912 photograph taken on the ladder tracks at the Ankeny Street carhouse. The building in the background, Kerns School, was replaced by a Coca-Cola bottling plant in the 1930s.

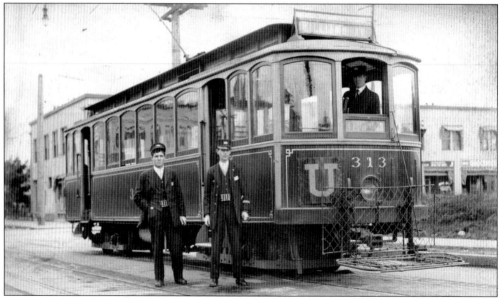

There is one conductor too many in this 1910s view of Williams Avenue Car No. 313 outside the Piedmont barn in North Portland. They are Rupert McGinnis, Talent (no first name given), and James Barrick, all of whom lived in a nearby rooming house on Minnesota Avenue. Their car, former Portland Railway No. 113, still has its Fuller "double purchase" lever-type handbrakes.

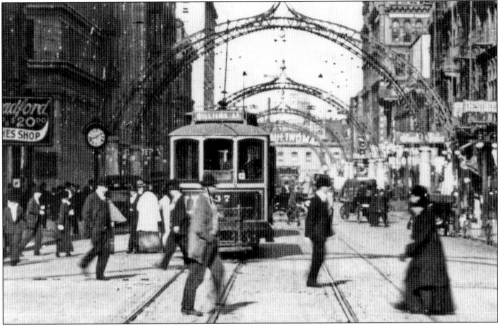

Office workers scurry across the intersection at Southwest Third Avenue and Alder Street while Williams Avenue No. 337 waits impatiently beneath the new illuminated arches. Third Avenue merchants financed this "Great Light Way" in June 1914, and it remained a landmark until the late 1930s.

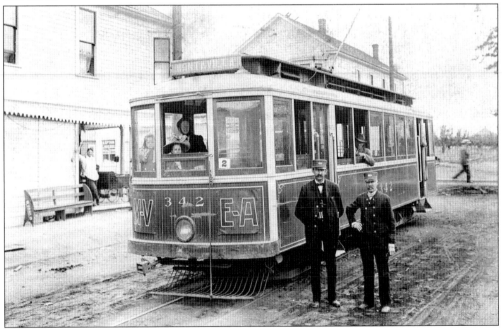

Even the grocer is "watching the birdie" as Montavilla Train No. 2, lays over at Southeast Eightieth and Stark Street on a warm day in 1913. By this time, the East Ankeny line had stopped running separately from Montavilla. Trolley No. 342 began as one of a dozen Fuller open cars. (Courtesy Mark Moore.)

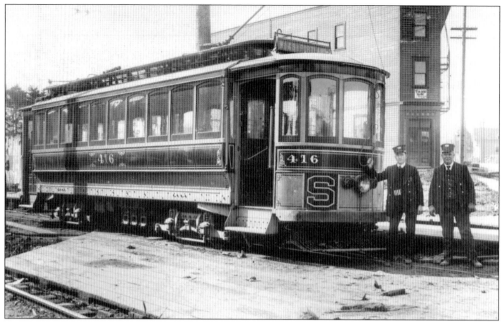

Motorman Philip Messner and an unnamed conductor enjoy a break at Northwest Twenty-first and Reed, the pre-1910 northern terminus of the North and South Portland line. Car No. 416, still wearing its elaborate original paint, is about to leave the gritty Slabtown area for the upscale Nob Hill neighborhood. (Courtesy Oregon Historical Society, ORHi 51198.)

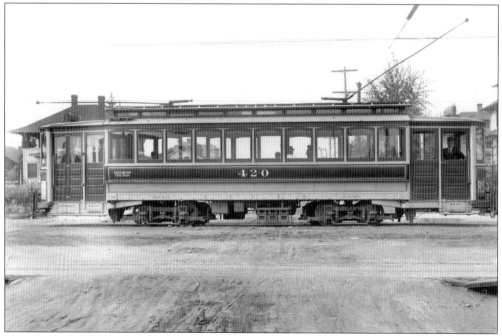

One-of-a-kind streetcar No. 420 was rebuilt in 1909 as a pay-as-you-enter (PAYE) car. However, the excessive overhang created by larger vestibules exacerbated the rough ride the 400-class cars were already known for, and the experiment proved unsuccessful. This photograph was taken at the end of the Russell-Shaver line at North Shaver and Concord in the Overlook neighborhood.

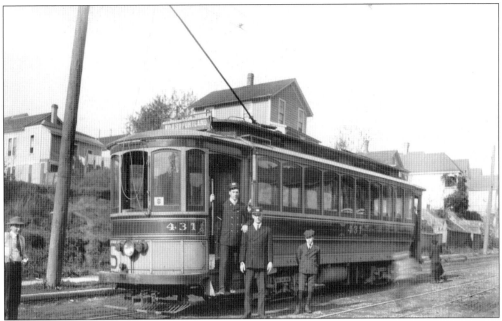

PRL&P Train No. 8 is working the North and South Portland run around 1912. The hilly location looks to be near the southern end of the line at Southwest Corbett and Seymour. Those students in "short pants" could well be on their way to Terwilliger School. Trolleys like No. 431 had begun replacing Fuller cars on the S line. (Courtesy Mark Moore.)

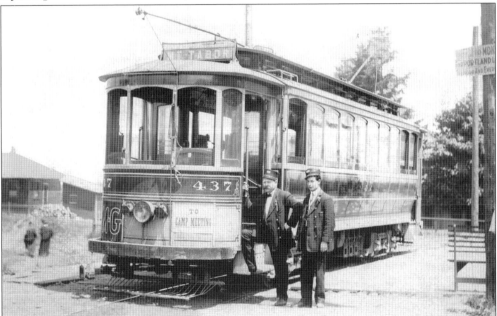

In this 1912 vintage view, Car No. 437 appears to be at the Mount Tabor Park stop near Southeast Eightieth and Yamhill Street. (Note the camp meeting sign on dash.) The sign on the pole reads, "Cars to Montgomery or Portland Leave on the hour and every hour." After the Lewis and Clark Exposition, the western terminus of the Mount Tabor line had been moved to Southwest Sixteenth and Montgomery Streets. (Courtesy Mark Moore.)

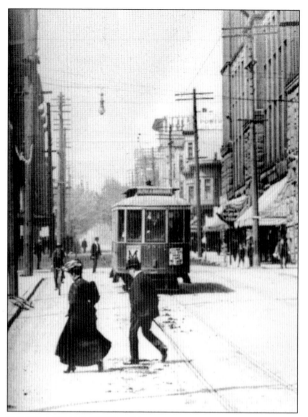

Depot & Morrison line Toronto No. 452 is gliding eastward through the intersection of Southwest Morrison Street and Sixth Avenue in a postcard scene published around 1908. The car was depicted in PRL&P's new livery of dark red with yellow-cream trim.

The weather outside is frightful, but the motorman has opened the window in this Jack Frost scene atop Council Crest. The photograph was likely taken in 1912, not long after the Toronto Series were equipped for hill duty with additional motors and magnetic brakes. Brrr!

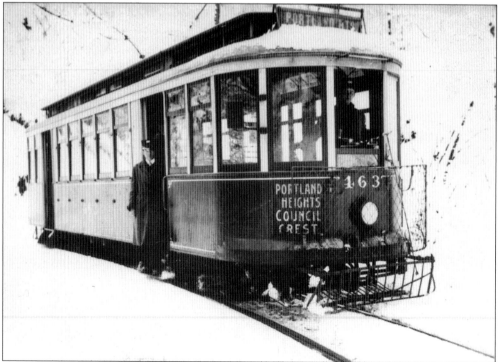

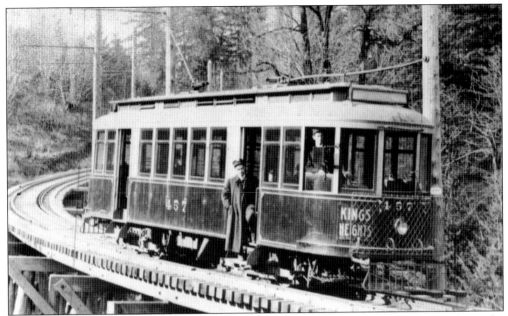

Toronto No. 457 has made an unscheduled, photograph stop in the middle of a trestle on the Kings Heights line. Note the rearview mirror on the corner of the car. This feature is not seen in later photographs of these units.

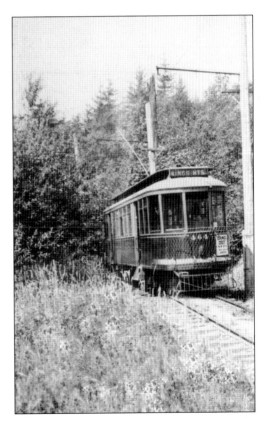

PRL&P No. 464 works upgrade on Kings Heights line private right-of-way, possibly on its way to Mount Calvary Cemetery. By the time this c. 1919 photograph was taken, the Torontos were usually assigned to the Arlington Heights, King Heights, or Westover lines, leaving the Council Crest run to the 501–510 class cars.

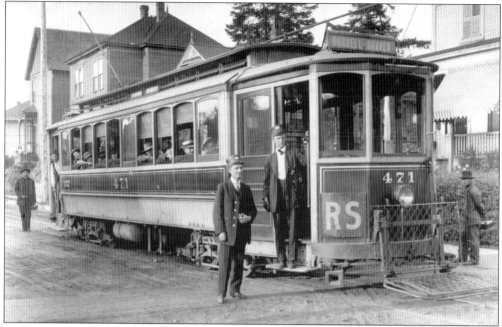

As streetcars were repainted over the years, paint decoration was simplified, as can be seen in this view of Russell-Shaver Car No. 471. Motorman Earl Crosson and conductor Paul Emanuelson have a good load as they prepare to depart for the Overlook neighborhood in North Portland. Real estate interests promoted the RS line, which began as a stub service in 1903.

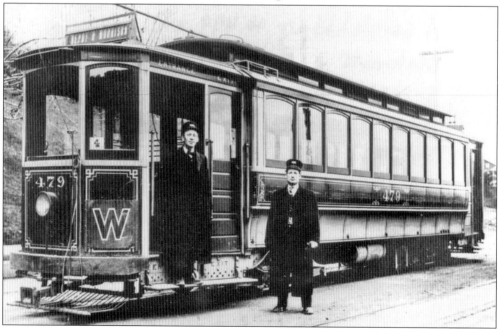

Depot & Morrison line Car No. 479 is seen at the end of the line on Northwest Thurman Street around 1910. The elaborate pin-stripping cannot hide the rather boxy looking ends on this new series of pay-as-you-enter cars (PAYE). Cars numbered 466 through 485 were the first PRL&P cars ordered with PAYE platforms, which featured separate entrance and exit doors.

This snapshot of Council Crest Car No. 501 includes an unexpected shadow. Was she a mother seeing off a child, or perhaps an admirer of the motorman? Notice that the only paving on the street was between the rails.

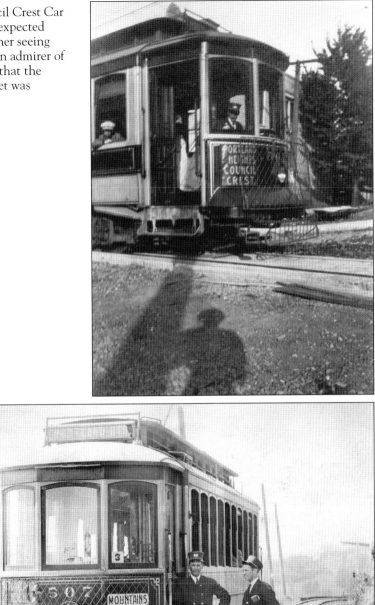

Motorman "Ches" and conductor Rudolph (leaning on switch iron) have brought Council Crest Train No. 3, Car No. 507, to the park on a sunny afternoon in the early 1910s. This was one of the stations to which the "Mountains in View" sign referred. A fine view of the Tualatin Valley and hills could be had from this point. (Courtesy Mark Moore.)

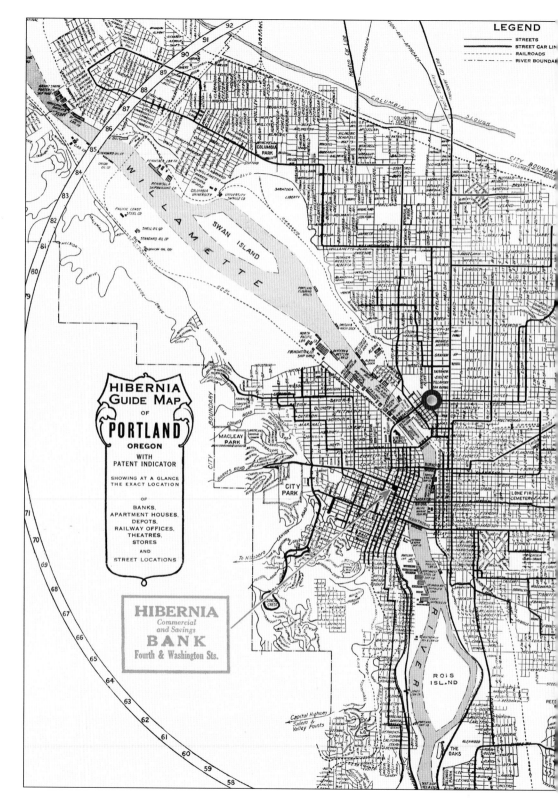

This guide map, prepared for the Hibernia Bank in 1920, shows the Portland Railway, Light & Power system at its height, with 38 city lines. The last new line was added that year, just as ridership began a slow decline.

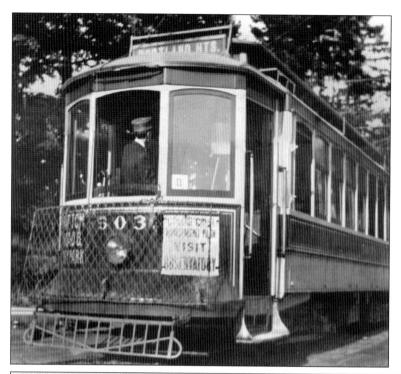

The conductor leans against the open window as Car No. 503 pulls away from a stop on the Portland Heights run. The photograph must have been taken during the late 1910s or early 1920s, since the trolley still has its metal brush guards, no retriever has been installed, and trim details lack fancy corner brackets. The dash signs read, "Patton Road & City Park" and "Council Crest Amusement Park Visit Observatory."

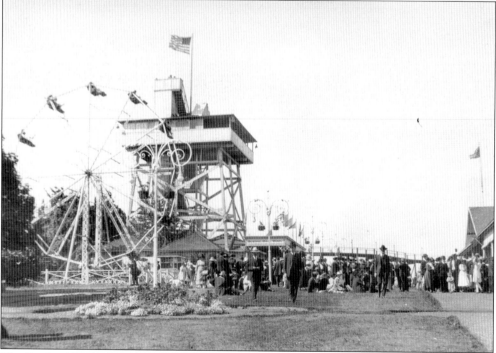

The Portland Railway, Light & Power Company built Council Crest Amusement Park in 1907, promoting weekend ridership with a Ferris wheel, scenic railway, dance pavilion, and observation tower. From an elevation of 1,200 feet, magnificent views were available in all directions. In 1929, the park closed after Jantzen Beach opened.

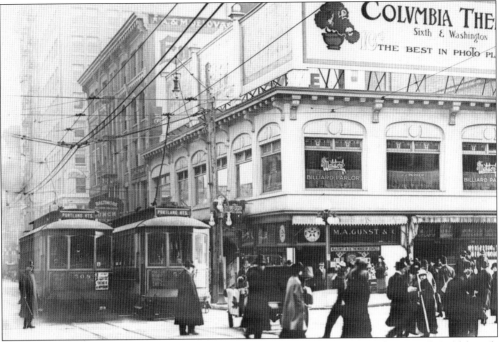

Sister Council Crest trolleys pass on Southwest Washington Street and Broadway, *c.* 1914. Although the policeman, in a period "Keystone Cops" uniform, presides mainly over pedestrians, open touring automobiles are now part of the streetscape. Note the arc lamp over the intersection.

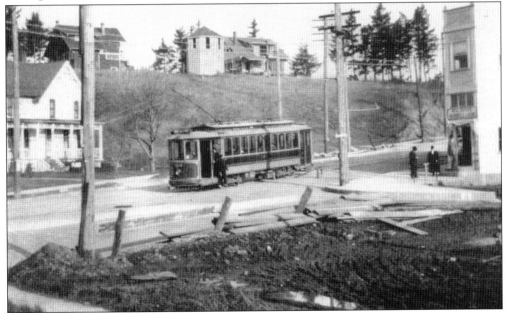

Passengers alight from the rear platform of Rose City Park Car No. 540 as it heads eastward up the hill on Northeast Sandy at Fifty-second Avenue, *c.* 1911. Two years previously, two young men received lengthy sentences for a nighttime robbery on this line. The holdup took place when only the crew was aboard. Note the pump house in the background. (Courtesy Mark Moore.)

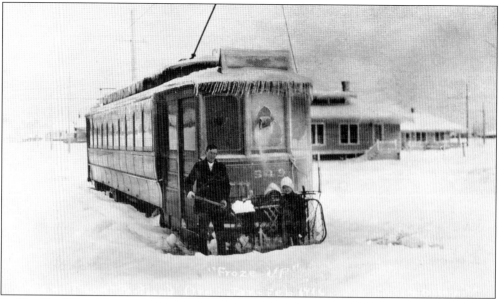

Trolley No. 549 is "froze up" in the silver thaw that followed the record storm of January 1916. In those days, crews stayed with their cars and kept as warm as possible until they could get underway again. The resourceful team of Cross and Dimmitt have located a shovel and they are attempting the hopeless-looking task of digging out their icicle-encrusted car. The location is unknown. (Courtesy Mark Moore.)

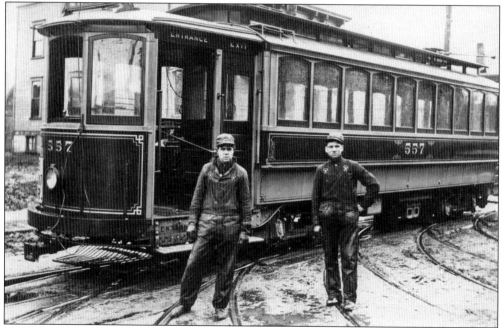

These Ankeny barn shop crewmen on Northeast Couch Street appear to be taking their work seriously, as they prepare Car No. 557 for work in the snow. However, in 1910, two less-dedicated PRL&P workers were arrested when they became intoxicated after a day's labor and took a car out of the barn for an unauthorized joyride through the downtown streets. The miscreants pleaded guilty and were fined $25 each. (Courtesy Mark Moore.)

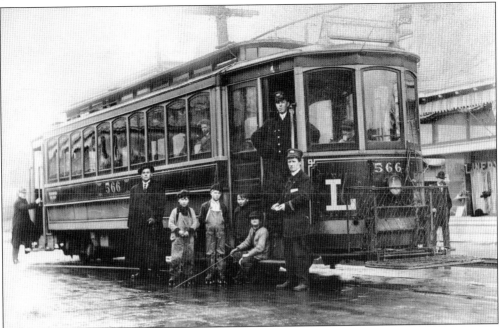

The gang's all here! Four boys on rollerskates while away their time with the crew of Car No. 566 during a layover on North Mississippi Avenue on the Lower Albina line. It is nearing noon on a rainy day in the mid-1910s. Hanging out with the trolley must have been more exciting than skating. The crew included Howard Cromwell and Delbert, or Geary, Gilkison.

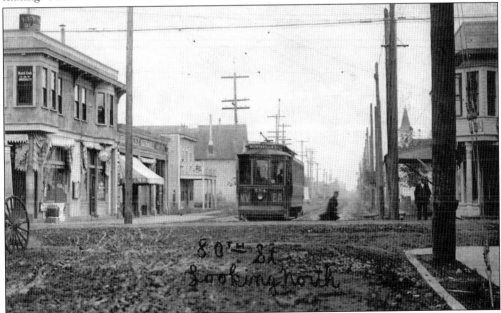

In 1911, Car No. 594 is at the eastern terminus of the Montavilla Line at Southeast Eightieth and Stark Street, before the extension of the line to the Mount Hood Railway depot on Ninety-first Avenue. The Marshall Brothers grocery store (now Dixon's Drug) is on the left and a dry goods firm on the right. One of the crewmembers appears to be scurrying across the muddy street. (Courtesy Mark Moore.)

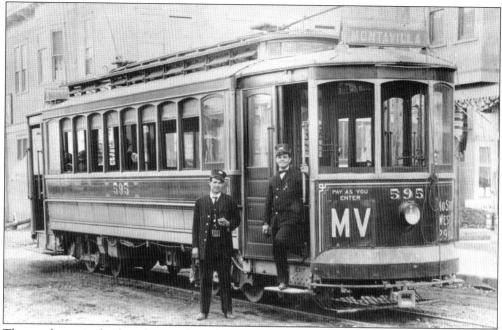

The conductor is checking his watch in this nicely posed portrait of Montavilla Car No. 595 at Southeast Eightieth and Stark Street around 1910. When the City & Suburban Railway extended its East Ankeny trolley here in 1892, the community was known as Mount Tabor Villa, but it soon adopted the contraction first seen on trolley roll signs.

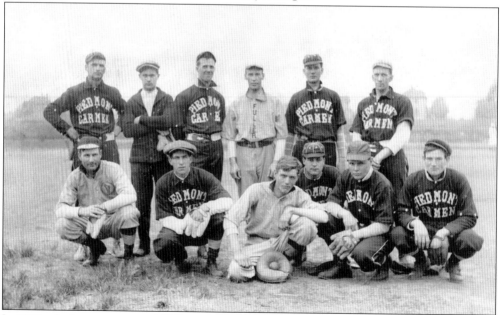

In 1906, platform men earned 27.5¢ an hour. Until the formation of Street Railway Employees Union Local No. 757 in 1917, many worked 7 days a week, 10 hours a day. Yet they still found time for off-duty activities in the carbarn clubhouse, including pool, boxing, and dances. Some formed baseball teams, such as the Piedmont Carmen. Such activities may help explain the overall lack of labor unrest.

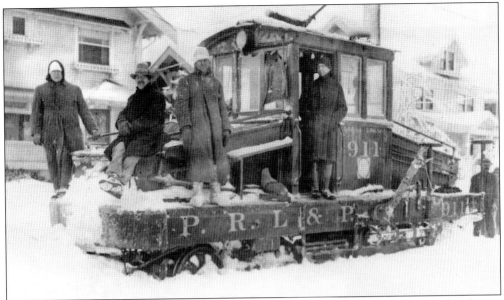

It takes all kinds of equipment to run a railway, as evidenced on February 13, 1916, by electric Locomotive No. 911 on snowplow duty on Northeast Glisan Street in Laurelhurst. PRL&P's two other narrow-gauge steeple cabs were assigned to unglamorous duty handling fuel at power stations, leaving No. 911 to serve a short-lived career as a freight motor on the city lines. Locomotive No. 911 was built in 1906 by Portland Railway.

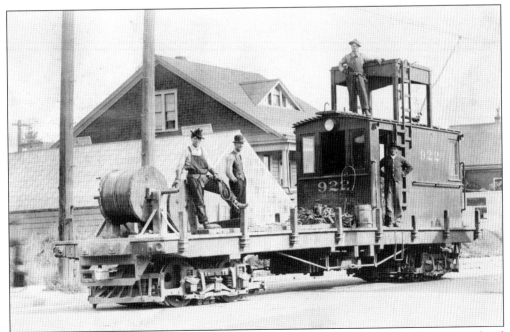

Pictured here is narrow-gauge line Car No. 922 in the 1910s, location unknown. Four-motored and magnetic braked, it went anywhere on the 42-inch divisions. The work car was built by PRL&P in 1913, rebuilt in June 1928, and not retired until the bitter end—February 28, 1950. Notice the large greenhouse in the background.

Who says a streetcar man could not cut a "natty" figure? The unidentified conductor leaning against a bungalow porch in this snapshot proves otherwise. In addition to attracting the attention of the opposite sex, platform men like this were heroes to young boys who dreamed of growing up to be carmen.

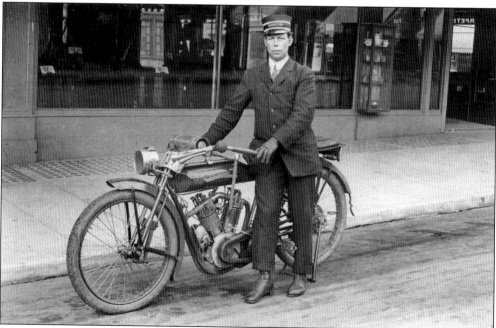

Inspector H. J. Baker cuts a rakish figure of another kind as he demonstrates a new way to quickly reach the scene of a breakdown. The year is 1913, and the motorcycle is a Jefferson. In later years, these men, who also made sure the cars ran on schedule, would be called supervisors.

*Six*

# STANDARD GAUGE TOO
## 1906–1924

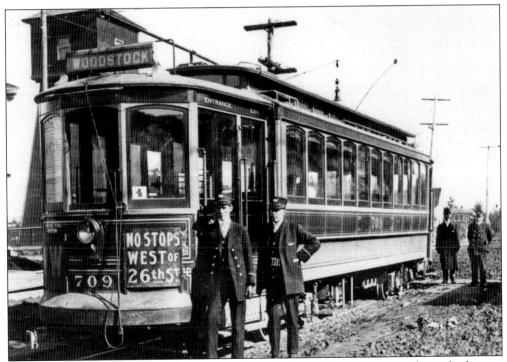

With the advent of the Portland Railway, Light & Power Company, several standard-gauge (four feet, eight and a half inches) routes were determined to have become more suburban, than interurban, and were equipped with new city-style streetcars. Such was the case with Woodstock Car No. 709, pictured here at the outer end of the line at Fifty-seventh Street and Southeast Sixtieth Avenue. Note the pump house in the background.

Oops! In this 1918 neighborhood scene, Richmond Car No. 702 is being rerailed after the front wheels jumped the track on Southeast Clinton Street. The camera is looking east between Southeast Thirty-third Avenue and Thirty-third Place. An inspector is surveying the mishap. His car, parked at curb to the left, bears a large sign on the windshield that reads, "Emergency."

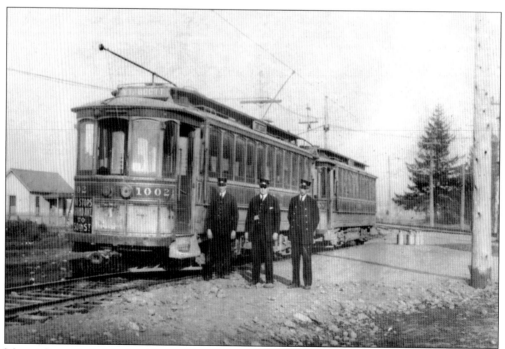

Mount Scott Train No. 1, with cars No. 1002 and No. 1009, sits at Lents Junction. The Sellwood Division platform men called the 1000–1015 Series cars "Yellow Jackets," a nickname derived from the dark red and yellow-cream colors introduced by PRL&P in 1907. This two-tone livery was quite a contrast to the solid color scheme used by OWP. Note the milk cans ready for loading next to the rear car.

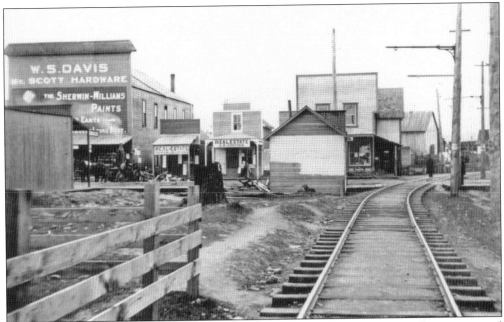

The Mount Scott line curves through Lents near present-day Southeast Ninety-second Avenue, c. 1913. The Mount Scott and Estacada lines met a few blocks down the track at Lents Junction. The growing community was served by a row of false-front shops, including the Mount Scott Hardware and two real estate offices. The O. R. Addition office in the center was promoting $3 lots.

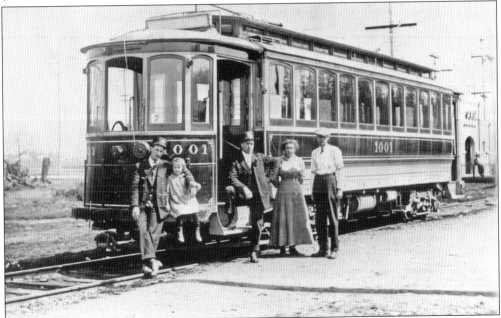

Around 1908, a station agent (in garters and golf cap) and his family are posing with the crew in a folksy portrait taken at Lents Junction in Southeast Portland. It may be a weekend afternoon, since heavy, four-motored cars like Yellow Jacket No. 1001 were usually run in high-capacity, two-car trains. The building in the background is Lents substation.

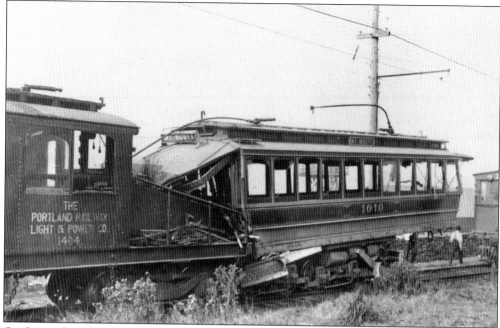

On September 22, 1909, a head-on collision between a two-car Mount Scott train and electric Locomotive No. 1404 occurred at Sellwood. Although severely damaged, Yellow Jacket No. 1010 was rebuilt with longer platforms and became a PAYE car similar to Nos. 1016–1010. The second car has already been removed in this photograph, and a box motor is preparing to extricate No. 1010. Steeple cab No. 1404 continued in service until 1940.

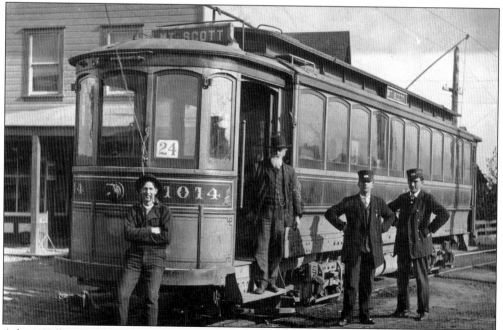

A lone Yellow Jacket makes up Mount Scott Train No. 24 in Lents around 1910. The crew is exhibiting interesting body language as a pipe-chomping man rests against the fender of their car and an important looking gentleman pauses on the step. (Courtesy Mark Moore.)

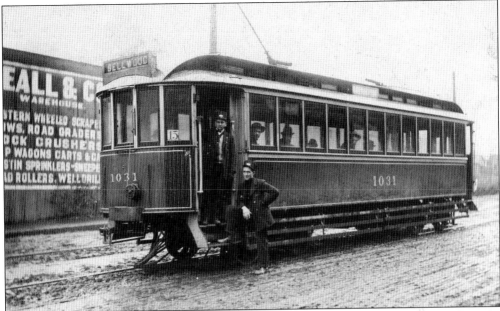

Motorman Elver E. Pease has come back to confer with his conductor as PRL&P Interurban No. 1031 pauses at First Avenue on its eastward journey along East Hawthorne Boulevard around 1910. Car No. 1031 and sister No. 1032 were standard-gauge, wooden interurbans rebuilt in 1901 by the Portland City & Oregon Railway in their Milwaukie shops. After rebuilding, they followed steam railroad patterns, including railroad roofs, high-speed trucks, and pilots (cowcatchers).

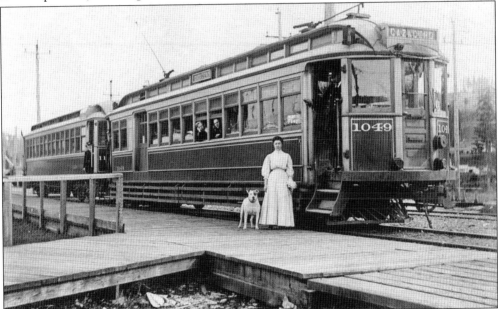

Mrs. Lowry and her dog are pictured on the platform in front of the Estacada Hotel in 1912. PRL&P employment examiner Howard R. Lowry and his family were staying at the company-run hotel. The metal Cazadero sign on this train, consisting of Motor No. 1049 and Trailer No. 1121, would soon fall out of use when the village at Milepost 33.4 burned. Trains began turning back at Faraday. (Courtesy Mark Moore.)

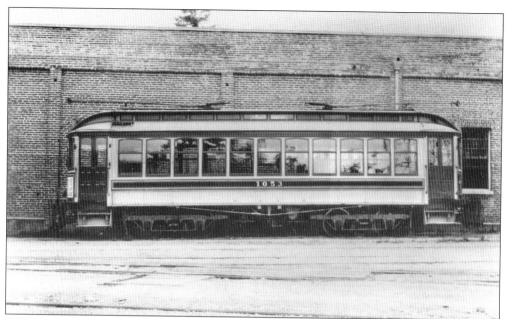

PRL&P No. 1053 held the unique distinction of having figured in a murder case. The alleged crime took place on December 30, 1908, and the headlines read, "Remains of Joe Wanas Taken From Under Sellwood Coach." It appeared that death had occurred from Wanas being struck by the trolley, but investigators suspected homicide. Although never proved, they believed the dead body had been placed on the rails following an altercation at a nearby club.

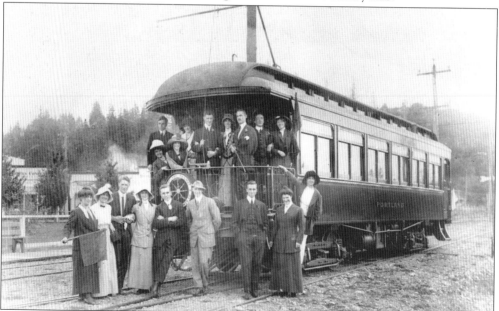

In September 1912, Mildred Josselyn, daughter of PRL&P president Benage Josselyn, and a party of friends rode the company's parlor car, *Portland*, to Estacada. The flagship car had been remodeled from an OWP interurban three years previously for use in executive inspection trips and charters. The beautiful 1905 Niles car sported colored-glass windows, carpeting, and upholstered wicker furniture. Note the illuminated Portland Railway, Light & Power drumhead.

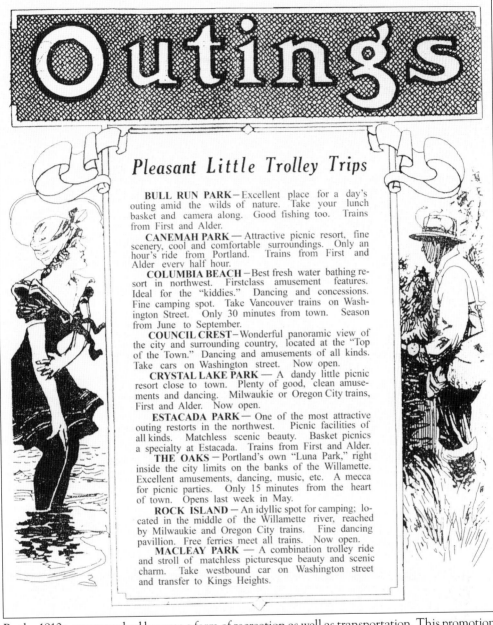

# Outings

## Pleasant Little Trolley Trips

**BULL RUN PARK**—Excellent place for a day's outing amid the wilds of nature. Take your lunch basket and camera along. Good fishing too. Trains from First and Alder.

**CANEMAH PARK** — Attractive picnic resort, fine scenery, cool and comfortable surroundings. Only an hour's ride from Portland. Trains from First and Alder every half hour.

**COLUMBIA BEACH** —Best fresh water bathing resort in northwest. Firstclass amusement features. Ideal for the "kiddies." Dancing and concessions. Fine camping spot. Take Vancouver trains on Washington Street. Only 30 minutes from town. Season from June to September.

**COUNCIL CREST**—Wonderful panoramic view of the city and surrounding country, located at the "Top of the Town." Dancing and amusements of all kinds. Take cars on Washington street. Now open.

**CRYSTAL LAKE PARK** — A dandy little picnic resort close to town. Plenty of good, clean amusements and dancing. Milwaukie or Oregon City trains, First and Alder. Now open.

**ESTACADA PARK**— One of the most attractive outing restorts in the northwest. Picnic facilities of all kinds. Matchless scenic beauty. Basket picnics a specialty at Estacada. Trains from First and Alder.

**THE OAKS** — Portland's own "Luna Park," right inside the city limits on the banks of the Willamette. Excellent amusements, dancing, music, etc. A mecca for picnic parties. Only 15 minutes from the heart of town. Opens last week in May.

**ROCK ISLAND** — An idyllic spot for camping; located in the middle of the Willamette river, reached by Milwaukie and Oregon City trains. Fine dancing pavillion. Free ferries meet all trains. Now open.

**MACLEAY PARK** — A combination trolley ride and stroll of matchless picturesque beauty and scenic charm. Take westbound car on Washington street and transfer to Kings Heights.

By the 1910s, streetcars had become a form of recreation as well as transportation. This promotion, which appeared in the *Portland News* on May 10, 1919, suggested nine different "outings," all reached, naturally, by trolleys of the Portland Railway, Light & Power Company. A variety of entertainment was possible—from hiking and picnicking to dancing.

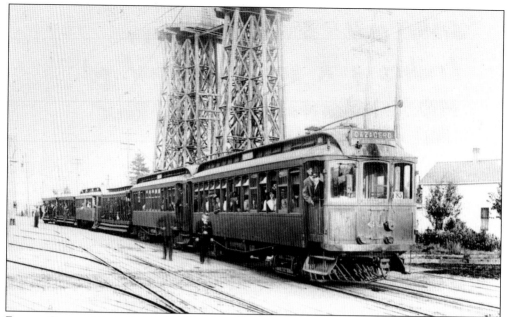

Former Oregon Water Power Car No. 63, not yet renumbered to 1063, is pulling a sister and four trailers in this 1910 view taken beneath the water towers at the new Sellwood barn. The motorman leaning out the front platform window is Albert A. Reck, who went to work for OWP in 1906, and retired from Portland Traction Company 48 years later at the age of 77. (Photograph by Fred L. Blaisdell.)

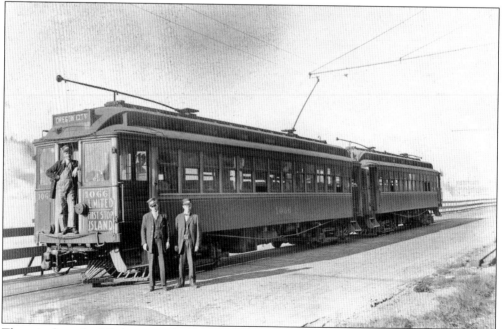

The mist from the falls hangs in the air as cars No. 1066 and No. 1065 layover at Canemah on a sunny day in 1915. The train was a limited, making no stops until it reached Island Station, south of Milwaukie. Note the pilot, or cowcatcher, and the difference in attire between overall-clad motorman Jesse James and uniformed conductors J. J. Shipley and John H. Hartranft.

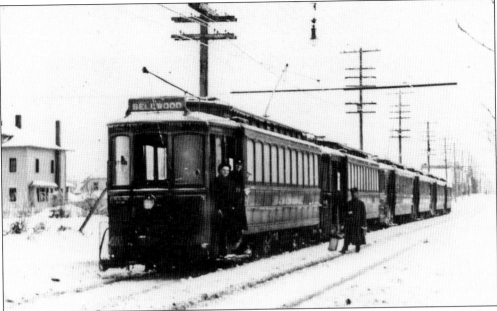

These three Mount Scott trains had to buck their way through the snow on their way back to the Sellwood carhouse. The location is thought to be Southeast Thirteenth Street and Clatsop, during the big snow of 1916. Cars in this series, numbered 1070–1091, were designed to run in multiple-unit pairs as seen here. These heavy suburban streetcars were replacing interurbans on the Mount Scott route.

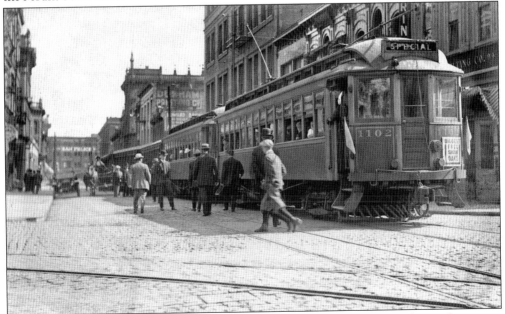

The last passengers are scampering as an excursion train makes ready to depart downtown Portland, probably near the OWP waiting room on the corner of Southwest First and Alder. Two 1092-class motors are in charge of a string of open 1200-Series trailers. These 51-foot, wooden interurbans, locally built in 1910 and 1912, were the cars the author's mother remembered best. (Courtesy Mark Moore.)

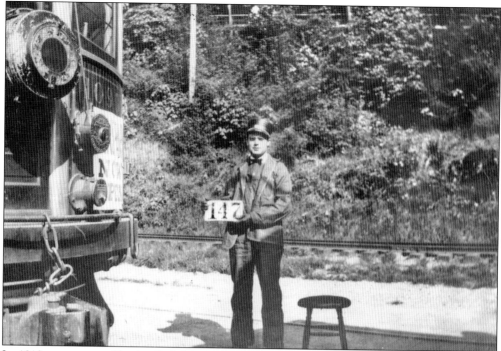

In 1910, motorman Charles B. Johnson displays the sign for Oregon City Train No. 147 at Canemah. The wooden stool at his side is typical of the stools interurban motormen brought along with them so that they would not have to stand while operating. Note the large, removable interurban headlamp. Photographs with headlamps are rare, since they were not usually hung on the front train door until near dark.

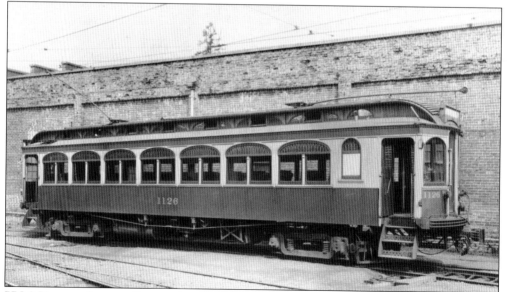

PRL&P's most elegant rolling stock was acquired in April 1912, with the purchase of the Mount Hood Railway and Power Company, which had rights-of-way from Portland to Bull Run. Four arched-window Kuhlman cars came with the deal. They were 10 feet longer than their closest competitors in the interurban beauty contest—Niles No. 1057 and No. 1058.

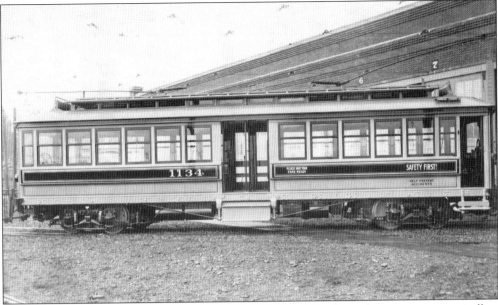

In 1913, PRL&P rebuilt four 1300-Series open cars to create the only regular center entrance trolleys used in Portland (except for articulated No. 100-101 and parlor car No. 1500). The photograph above documents No. 1134 as it appeared when newly out-shopped at Center Street.

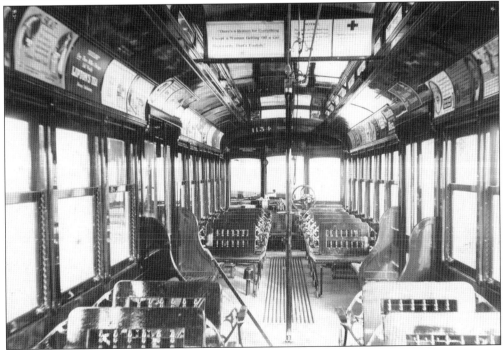

The interior of Car No. 1134 reveals narrow, walkover, wooden seats and the center pay-as-you-enter area. With no bulkheads, the motorman's station is also clearly in view. Among the many advertising cards is one in the center ceiling reading, "There is a Reason for Everything. Except a Woman Getting off a Car Backwards. That's Foolish," likely a reference to the restricted mobility caused by the hobble skirts then in fashion.

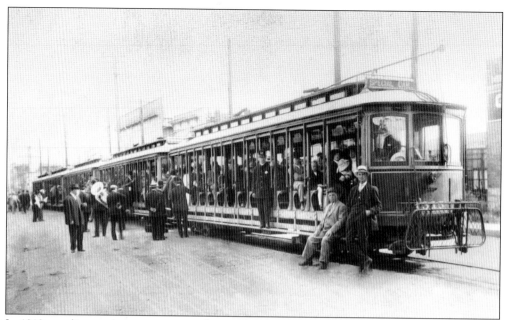

In 1910, a policeman's excursion, complete with brass band, is boarding five 1300-Series trolleys on Water Street at Southeast Morrison Street. The officers are in uniform, but motorman Bill Murray (sitting on the running board) and conductor Bert Baird (in straw hat) are not. These handsome center aisle open cars were also used as trippers on the Mount Scott line and for Sunday service to Milwaukie. (Photograph by Fred L. Blaisdell.)

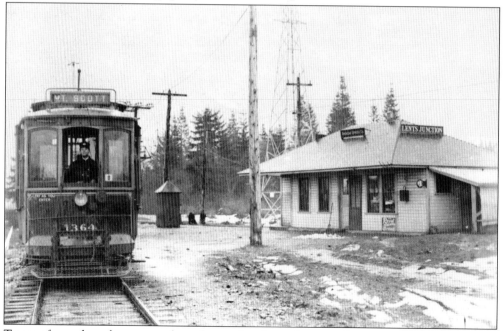

Traces of snow have been swept from the porch at Lents Junction Station as Mount Scott Train No. 8 pulled up in this scene from the winter of 1912. Car No. 1364 was the last standard-gauge PAYE ordered from the American Car Company. Note the American Express Company sign on the station roof. (Photograph by Fred L. Blaisdell.)

In March 1912, PRL&P chief dispatcher Clyde R. Bartlett sits in his office in the Hawthorne Building. Bartlett had the difficult job of issuing orders controlling the movement of interurban passenger and freight trains. Unlike mainline railroads, interurbans utilized the telephone, rather than the telegraph, to communicate with crews. Check out the Home telephone on left side of the desk, and the railway telephone handset, mouthpiece, and switchbox in the center.

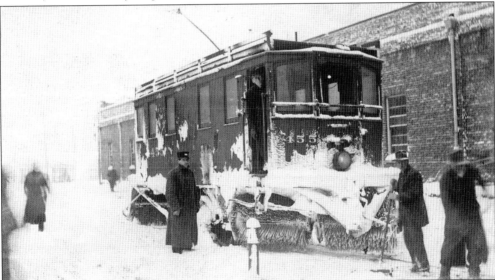

Snow sweeper No. 1455 joins in the Herculean effort to clear the track adjacent to the Sellwood barn during the great snow of January 1916. Car No. 1455, also known as "The Broom," is the oldest surviving Portland trolley, having been built by McGuire in 1899. Now in the collection of the Oregon Electric Railway Historical Society, it was last used for snow removal in January 1954. (Courtesy Mark Moore.)

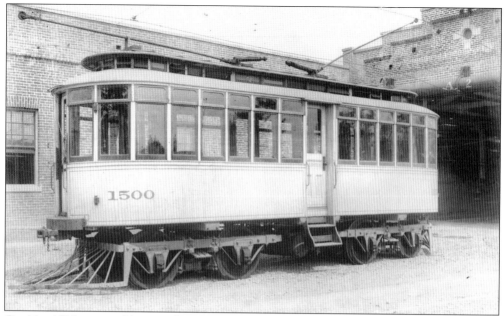

Car No. 1500, pictured here in front of bay A2 at the Sellwood barn, had a long and varied history. It was originally an experimental single-truck, gas-electric car built by the Patton Motor Car Company in 1892. Initial use on the Metropolitan Railway's standard-gauge lines proved a failure, but the vehicle was saved from the scrap heap around 1903 and converted into a double-truck electric car.

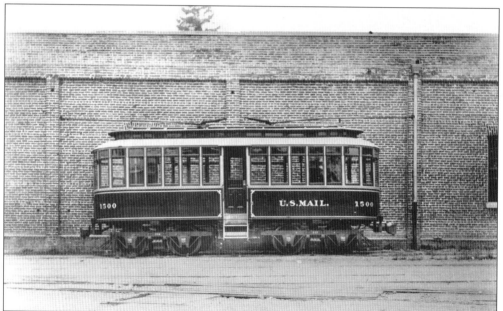

Over the years, this unusual trolley served as an interurban, parlor car (until replaced by the *Portland* in 1909), funeral car (train doors facilitated casket loading), mail car, and a city passenger car. By retirement in 1921, it was the only center entrance car to have remained in service for any length of time. This July 1, 1917, photograph shows No. 1500 as remodeled for emergency mail service.

# Seven

# SLOW FADE
## 1924–1958

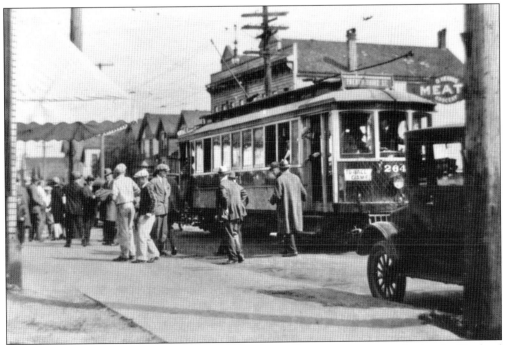

On April 26, 1924, the Portland Railway, Light & Power Company was reorganized as the Portland Electric Power Company (PEPCO). Although a vigorous improvement plan was put forward, the decline of electric street railways was underway. As ridership began to drop, streetcars were converted to one-man operations and the company began purchasing buses. Pictured here around 1924 is PEPCO No. 264 running as a Twenty-third line ballpark special on Northwest Thurman Street at Twenty-fourth. PEPCO No. 264 was once a Council Crest open car.

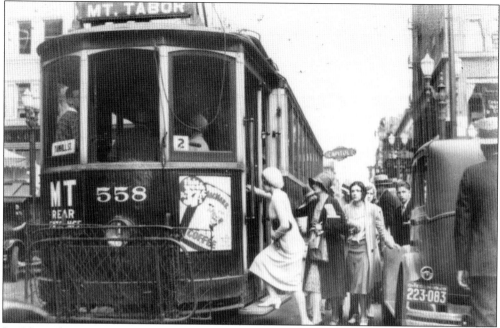

It is November 1929, and these downtown shoppers boarding the Mount Tabor car at the southwest corner of Fifth Street and Morrison Street seem blissfully unaware that the Great Depression has begun. PEPCO No. 558 is still in respectable condition, with Nelson safety fenders and a two-man crew. In a few days, it will be converted to a one-man operation.

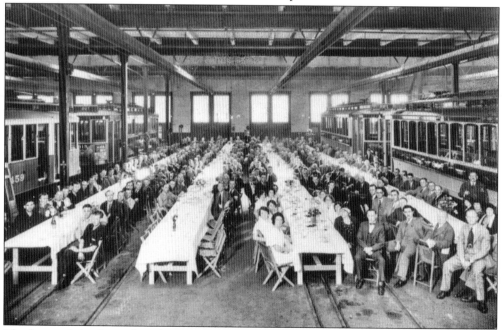

The financial clouds may have been gathering, but transit company employees still convened for a 1930 Christmas dinner. The Center Street shops provided a less than elegant setting for the event. Nine months before this happy photograph was taken, the company had again been reorganized, this time under the short-lived name Pacific Northwest Public Service Company.

In 1931, the Pacific Northwest Public Service Company sold a large amount of stock using their employees as salespersons. Some talked their friends and relatives into buying, at a time when few could afford the risk. In due time, the stocks were found to be nearly worthless. One of these employees, motorman Alois J. Halemba (at right) became so despondent over his part in the fiasco, that on the night of February 19, 1932, he stopped his empty Rose City Park streetcar on the Burnside Bridge and jumped over the side.

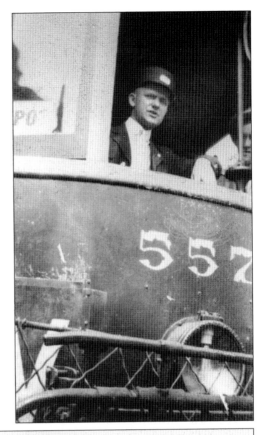

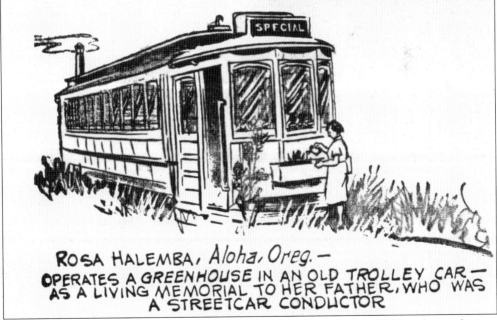

ROSA HALEMBA, Aloha, Oreg. —
OPERATES A GREENHOUSE IN AN OLD TROLLEY CAR —
AS A LIVING MEMORIAL TO HER FATHER, WHO WAS
A STREETCAR CONDUCTOR

Alois Halemba's daughter Rosa obtained retired Car No. 707 in the late 1930s and turned it into a gift shop in Aloha. The drawing illustrating her tale appeared in *Railroad* magazine.

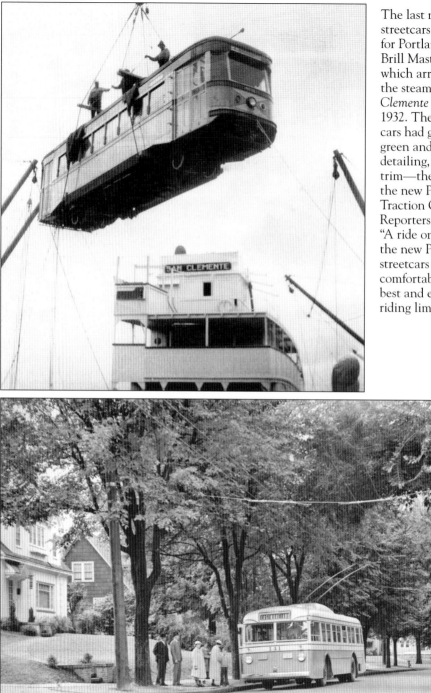

The last new streetcars purchased for Portland were 15 Brill Master Units, which arrived aboard the steamer *San Clemente* on April 30, 1932. These attractive cars had gray bodies, green and black detailing, and cream trim—the colors of the new Portland Traction Company. Reporters enthused, "A ride on one of the new Portland streetcars is about as comfortable as on the best and easiest-riding limousine."

The first buses to replace streetcars were trolley buses. On August 30, 1936, Portland Traction inaugurated the largest single installation of trackless trolleys up to that time. The first line was Eastmoreland. In 1924, gasoline buses had debuted on the new crosstown Thirty-ninth Street line but made little impact on streetcars. By the time the trolley coaches were discontinued in 1958, they would be the city's last electric transit vehicles.

THEY'RE SAFE ON THE PORTLAND STREET CARS

# $1.25 WEEKLY PASS

● Not Redeemable        ● Not Good on Inter-urban or Park Rose Lines

Pass bearer on all Portland City System street cars and/or buses of the Portland Traction Company between dates shown on this pass, both inclusive. This weekly pass is valid only for transportation of the passenger presenting same, and it must remain in possession of passenger during entire ride, or full tariff will be collected. It is void if tendered for passage by any other person for identical ride on same trip of car or bus. Pass must be shown and is subject to inspection at any time by conductor or operator.

DECEMBER -1934
9  TO
DECEMBER - INC.
15  Form 215

Portland Traction Co.
Portland City System

W. N. Lines.
VICE PRES. & GEN. MGR.

4448

In the 1930s, the Portland Traction Company began selling weekly passes, many of which featured colorful illustrated announcements on the front and advertisements on the reverse. This 1934 pass encourages parents to send their children to school on streetcars, a safe form of transit.

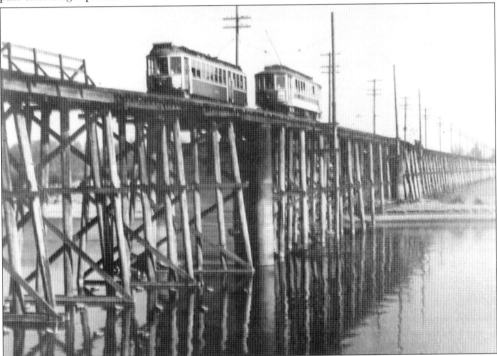

Looking south across the Columbia Slough, one can see Vancouver-bound Car No. 192 passing inbound Car No. 272. This would be the last decade for the line, which was converted to bus in 1940. The 191-class, narrow-gauge interurbans were unique, featuring railroad roofs, center doors, and bench seats running clear around the rear compartment. They had two poles but were single enders. The one at the front was for emergencies only.

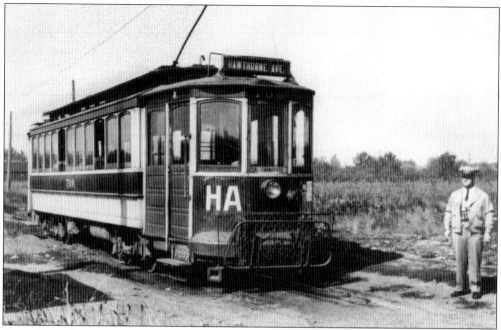

Does this trolley appear to be laughing at the motorman's "spiffy" new bus driver-style uniform? Standard-gauge Car No. 706 is laying over at the Southeast Seventy-fourth and Woodward terminus of the Hawthorne line during the last days of operation. The year was 1936, and the HA run was about to be converted to trolley bus. Note how undeveloped the area was at the time.

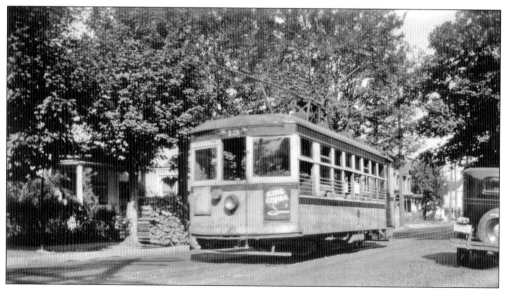

In 1918, 25 Birney cars were leased from the government to aid in transporting defense workers. The war had been over for two months when the little single-truckers arrived, but they were soon purchased and used for the next 20 years on lightly traveled lines. Here Birney No. 13 cavorts through Slabtown (note cordwood at curb) on a warm day in the 1930s, probably working the Sixteenth Street or Thirteenth Street lines.

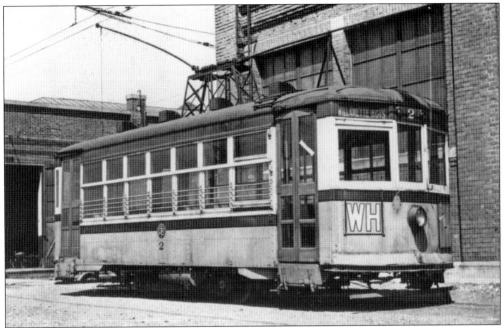

Birney Car No. 2 rests at the Center Street shops on the last day of service for Birneys—July 10, 1939. In 1926, rear exit doors had been added, and note how high off the roof the trolley pole was mounted. The Willamette Heights sign had been permanently painted onto the dash by this time.

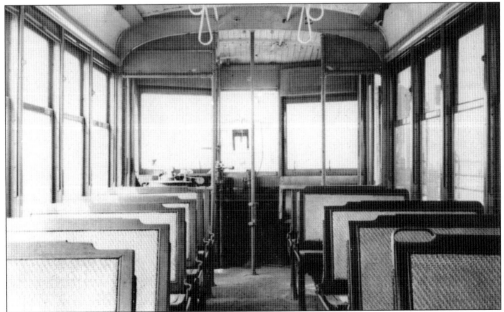

On July 10, 1939, an interior view of the last Birney is shown at Center Street. These four-wheel "bobbers" did not provide the smoothest ride but were popular with management since they were the original one-man cars. Low capacity (34 passengers) limited their use to lightly patronized lines, including Russell-Shaver, Sixteenth Street, Fulton, Irvington, Williams, Willamette Heights, or stub lines Thirteenth Street, Eastmoreland, and Murraymead. Two Birneys were standard gauge.

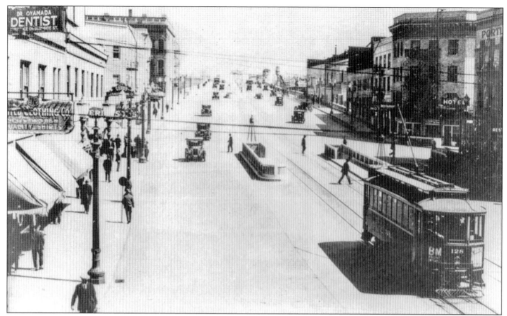

After the arrival of the Birneys, Car No. 128 and its mates were relegated to light duty, but they were working their last decade when this photograph was taken on West Burnside at Third Avenue. Both the Beaumont streetcar line and the outdated trolley that served it were retired in 1936. Northeast Forty-second Street was widened that year, the poles removed, and the BM converted to gas bus.

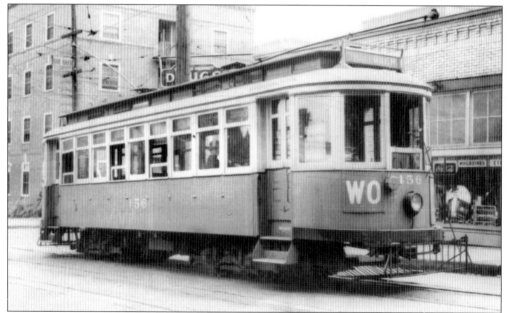

As it growls upgrade on Northwest Northrup just past Twenty-third Avenue, Westover No. 456 is sporting the apple green and cream color scheme chosen in a 1930s school contest. In the background are the nurse's quarters at Good Samaritan Hospital. Time is running out for the Westover, Arlington Heights, and Kings Heights lines, which were converted to bus in 1940 and 1941.

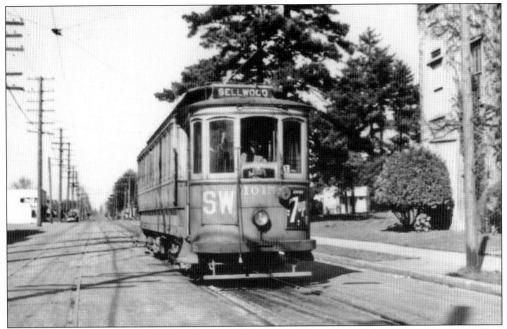

From 1936 until its conversion to trolley coach in 1940, the Sellwood line was served by Yellow Jackets 1001–1015 and PAYE cars 1016–1020. In the scene above, Car No. 1015, wearing apple green and cream livery, has reached the end of the line at Southeast Thirteenth Street and Ochoco. The old OWP substation is on the right.

For those learning to operate a trolley, No. 1020 was "utter simplicity." Pictured, from left to right, the equipment included an electric heater, a lever for opening the folding entrance door, a GE C-6K controller (much skinnier than the K type seen on most city cars), an adjustable stool, a notched belt for holding the center window open, a Westinghouse-type M air brake control, a Westinghouse air brake gauge (that read up to 160 psi), and a goose-necked mechanical brake.

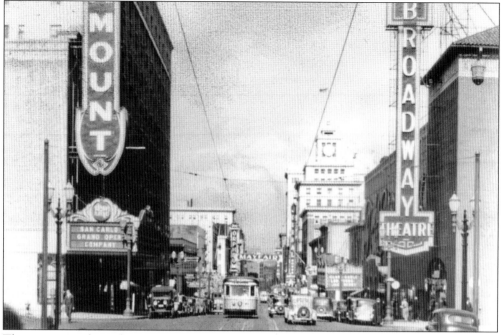

The car approaching the camera on Southwest Broadway at the intersection of Main Street is an 800 Series Broadway, working its namesake line. The original livery of gray, dark green, and black is still intact in this *c.* 1938 scene. The Paramount Theater at left, which was built as a vaudeville house in 1927, still stands as part of the city's performing arts center. (Courtesy Oregon Historical Society, ORHi 17624.)

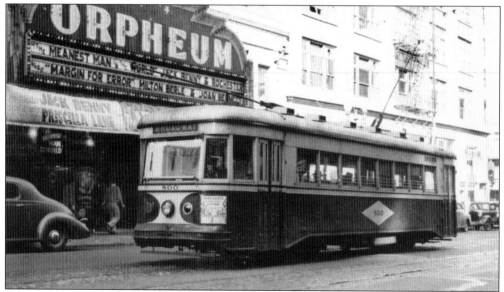

Broadway Car No. 800 is passing the Orpheum Theater on Southwest Broadway at Yamhill Street. Colors have now been changed to the maroon and cream with black trim of the last years. The movies on the marquee were released in 1943. In 1948, the Broadway line was converted to bus. These cars remained PTC's most popular, although there were complaints about them creating a lot of radio interference.

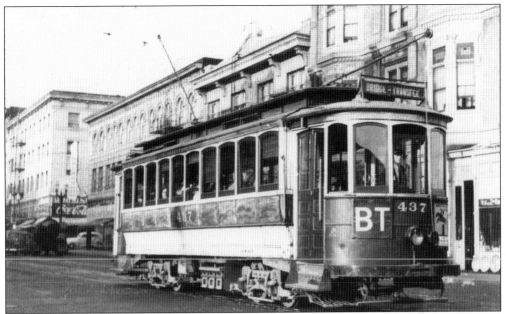

Neglected-looking veteran No. 437 is southbound on Grand Avenue, approaching Southeast Washington Street. It is September 1947, and the Bridge Transfer line is about to be converted to bus. Interestingly BT held the distinction of being converted twice. The first time came in 1940, but it was returned to trolley operation in 1941 due to wartime fuel shortages. New asphalt actually had to be chipped off the tracks.

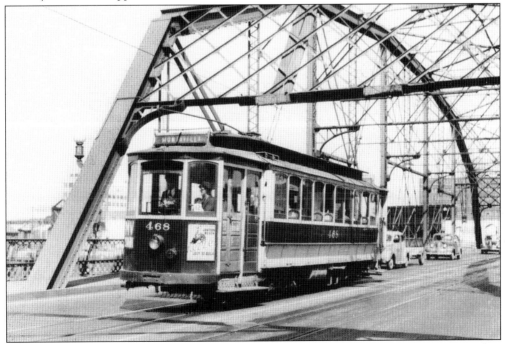

In this 1940s view, Montavilla tripper No. 12 is trundling westward over the old Morrison Bridge. It is a sunny day and most of the windows on Car No. 468 are open. This series of American Car Company PAYE streetcars lasted until 1948, the end for the MV line.

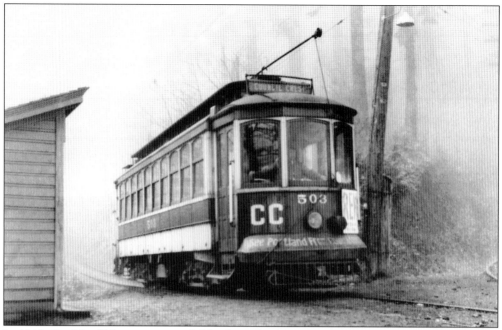

In 1948, Car No. 503 emerges wraith-like from the fog on Council Crest. It is now a one-man trolley. In 1939, Council Crest was the last line to be converted to a one-man operation. Today No. 503, along with sister No. 506, is preserved at the Oregon Electric Railway Historical Society Museum in Brooks, Oregon. (Photograph by Alfred L. Haij; courtesy haijonrails.com.)

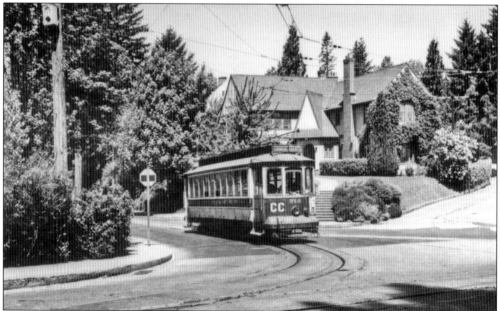

Council Crest No. 510, seen at Southwest Vista and Patton Road, would soon be scrapped after it caught fire on November 12, 1948. Everyone escaped unhurt, but such was not the case when similar fires took place in other CC cars in 1949. In February and May, passengers were injured jumping through windows. James Johnson, the unlucky motorman both times, suffered burns. Note the block signal at left. (Photograph by Alfred L. Haij; courtesy haijonrails.com.)

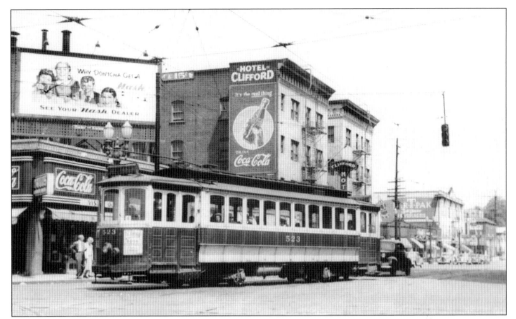

Mount Tabor No. 523 is turning west onto Grand Avenue from Southeast Morrison Street during Vanport flood rerouting. In 1942, Vanport City was built on swampland just south of the Columbia River to house defense industry workers. Due to the postwar housing shortage, nearly 19,000 were still living there when a dike gave way on May 30, 1948. This was the final year of operation for the MT line.

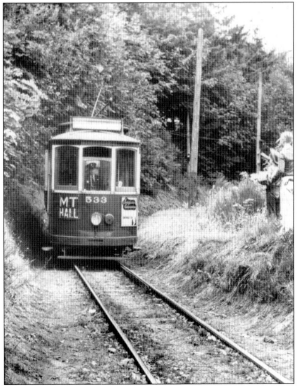

Kids wave at Mount Tabor Train No. 2, Car No. 533, as it emerges from the private right-of-way next to Mount Tabor Park between Southeast Taylor and Belmont Streets. There were three short sections of off-street running like this on MT. The clock is ticking for No. 533, which was retired in 1948.

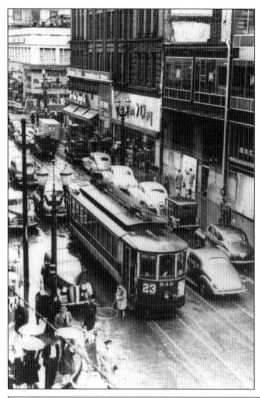

On January 4, 1948, Twenty-third Avenue Car No. 543 heads east on Southwest Washington Street at the corner of Sixth Avenue. The line would be converted to bus in two years, after which Washington Street would succumb to Mayor Dorothy McCullough Lee's one-way street grid.

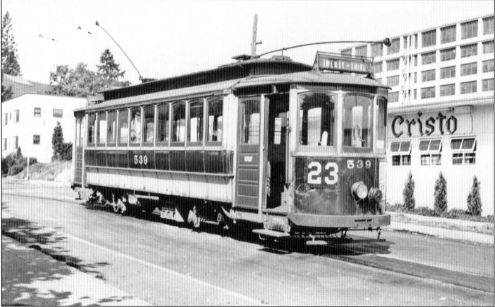

In the last days, Car No. 539 waits disconsolately for its operator to return from a break at the Monte Cristo Restaurant on Northwest Twenty-seventh Street and Upshur. This was the location of the Fairground Loop during the 1905 Lewis and Clark Exposition, and the roof of the old Forestry Building (which burned in 1964) is just visible in the background. Montgomery Ward is in the right background. (Courtesy James Freeman.)

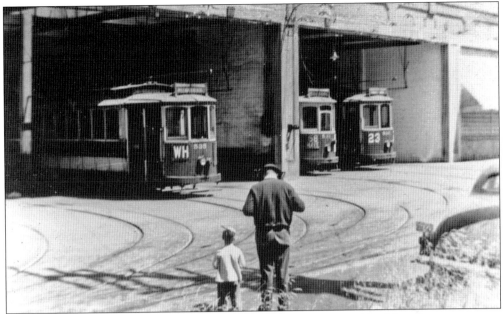

A father and son are documenting the last days of city streetcars in this poignant scene at Southeast Ankeny Street and Twenty-eighth Avenue. They are standing in front of the newest of the three Ankeny Street barns, a concrete structure built in 1910. The Ankeny division was discontinued on June 16, 1951, although trolley buses were kept here a bit longer. In 1962, the building was sold to the Archdiocese of Portland.

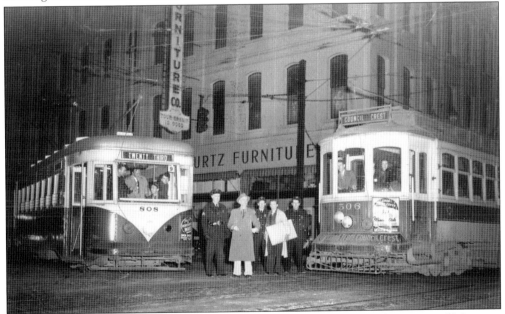

On February 26, 1950, cars No. 808 and No. 506 met at Southwest Second Avenue and Morrison Street after completing owl runs loaded with traction fans (including Charles Hayden in the center window of No. 506). The last three city streetcar lines—Twenty-third Avenue, Council Crest, and Willamette Heights—ceased operation that night. The next day's headlines proclaimed, "Street Cars Clang Death Knell" and "This Was the Day the Trolley Passed Away."

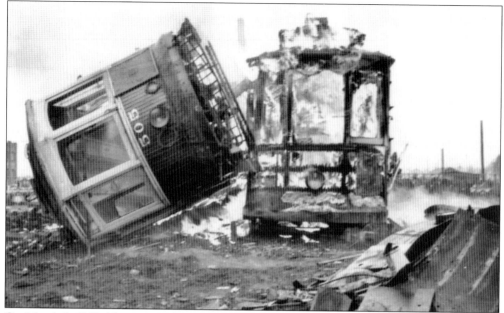

On March 9, 1950, like many others before and after, Council Crest cars No. 501 and No. 505 were unceremoniously burned for scrap metal on the Center Street rip track. The caption on the back of this photograph reads, "Last two cars scrapped and bodies burned." However, sisters No. 503 and No. 506 were preserved for future display and now reside at the Oregon Electric Railway Historical Society Museum in Brooks, Oregon.

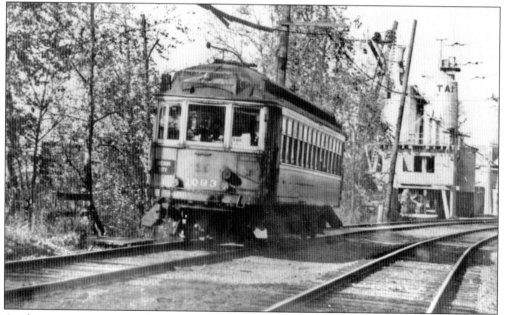

As the city streetcars vanished, two interurban lines soldiered on, providing the last electric railway service in the metropolitan area. They were Bellrose (new terminus of the Gresham line) and Oregon City. At first, the 1092-class, wooden interurbans, gussied up in new paint schemes, continued to shoulder much of the work, as with Bellrose No. 1093, pictured north of the Ross Island Bridge in orange and cream colors on November 5, 1949.

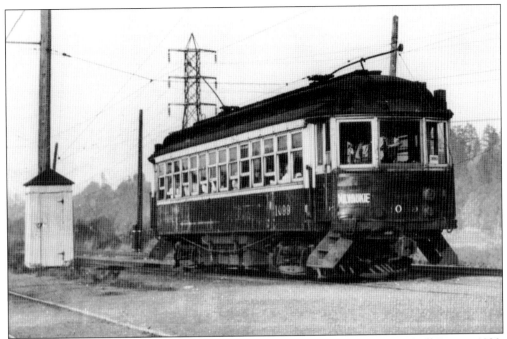

Passenger service on the interurban lines had been cut back over the years—Bull Run in 1930, Cazadero in 1932, Boring in 1934, and Gresham in 1949. Even so, the Bellrose and Oregon City lines continued to offer an interesting mix of regular and tripper service, such as this well-patronized Milwaukie local, resplendent in dark blue and cream.

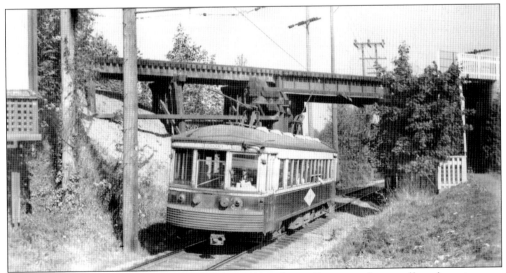

In its declining years, Portland Traction operated a collection of secondhand equipment purchased from around the country by superintendent Edward Vonderahe. The first of these, Car Nos. 4000–4005, were bought in 1940. They were built in 1927 by Kuhlman for the Interstate Public Service Company of Indiana. In this photograph, Oregon City Car No. 4000 is approaching Island Station, south of Milwaukie, the place where the author first caught trolleys with his grandmother.

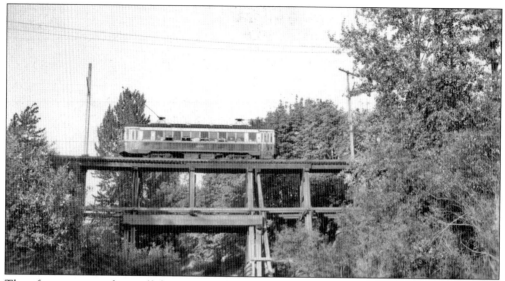

The afternoon sun glints off the stressed-skin sides of Indiana Car No. 4001 as it traverses the Johnson Creek trestle in Milwaukie. Although newer cars like these were an improvement for PTC, superintendent Edward Vonderahe never paid more than scrap value for any of them. His wife, Xarissa, helped him choose cars during buying trips around the country. Today 4001 is preserved at California's Western Railway Museum as Indiana No. 202.

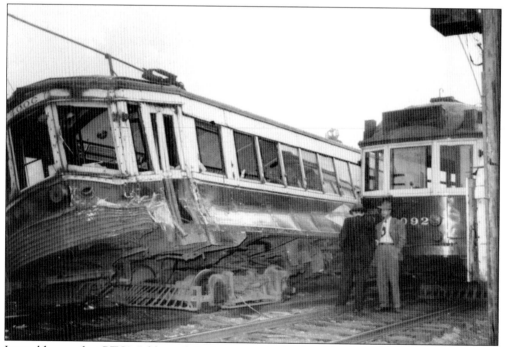

It would seem that PTC's "old woodpiles" were not intimidated by the newer streetcars. Car No. 1092 put Car No. 4000 out of commission permanently when the two met in the fog where the two tracks joined at Meldrum Crossing on the Oregon City line. Four people received minor injuries in the accident, which took place on November 5, 1949. The trucks from No. 4000 were fitted to city Car No. 813, creating interurban 4012. (Photograph by Alfred L. Haij.)

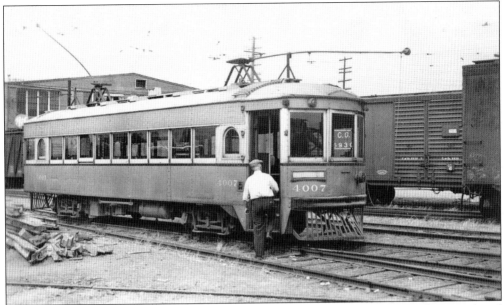

Master mechanic Roy Reinke clambers aboard one of Portland Traction's second group of used streetcars. In 1941, PTC purchased cars No. 176 and No. 177 from the Fonda, Johnstown & Gloversville Railway in New York State. These Cincinnati Car Company products, renumbered 4006 and 4007, were the best in the yard. However, small capacity restricted their use and they were seldom seen in the 1950s.

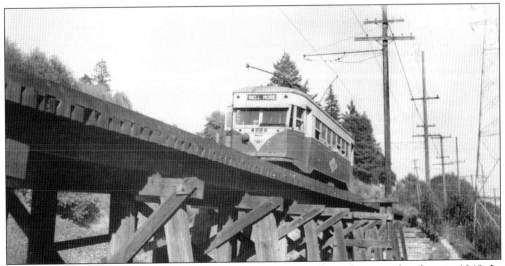

"Yak" 4008 growls across the Stanley trestle in a Bellrose-line photograph taken in 1949. In 1947, Portland Traction added three of these Brill Master Units to its fleet. Ex-Yakima Valley Transportation Nos. 20–22, built by American Car in 1930, looked very similar to Portland's Broadway trolleys. After extensive refurbishing at Center Street, they went to work as PTC Nos. 4008–4010. All three are preserved today under private ownership.

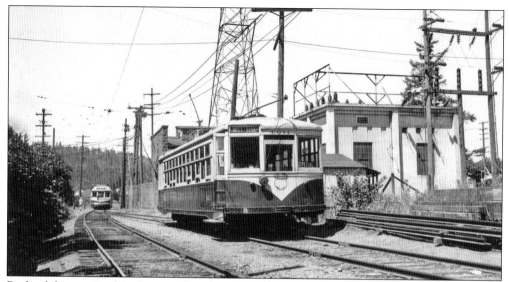

Both of the cars in this photograph, taken at Golf Junction on July 11, 1953, during a museum charter, are preserved today. Car No. 4011, built as Key System No. 987 in 1926, was on loan from the California Railway Museum from 1949 to 1958. Changes made to permit interurban operation included larger wheels and removal of the built-in headlight. Hollywood Car No. 4022 (in the background) is now at the Seashore Trolley Museum in Kennebunkport, Maine.

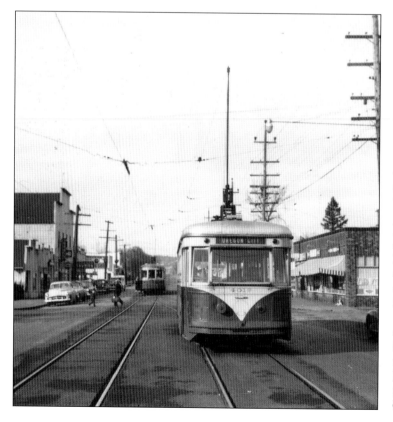

Former Broadway cars No. 813 and No. 800 were rebuilt in 1950, becoming Interurbans No. 4012 and No. 4014. Interurban No. 4012 received running gear from wrecked ex-Indiana No. 4000 and operated successfully until the end of service in 1958. It is pictured here with an Indiana car in Gladstone. Interurban No. 4014's conversion was unsuccessful, and it was scrapped in 1954. Interurban No. 4012, restored as No. 813, now resides at the Oregon Electric Railway Museum. (Photograph by Charles E. Hayden.)

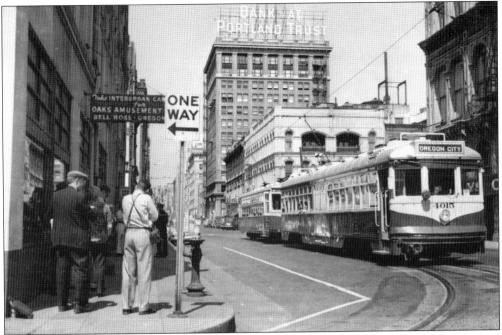

The last "new" cars added to the Portland Traction roster were eight ex-Pacific Electric Hollywood cars bought in 1953. Reportedly in poor condition when received, little restoration was done, with resulting breakdowns and trouble. In this photograph, Car No. 4015 and ex-Oakland Car No. 4011 are waiting at the First and Washington Street station. Check out the neon "Take Interurban Cars Here" sign.

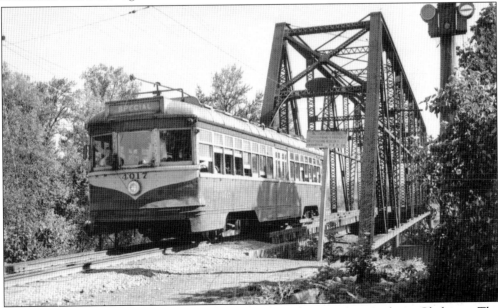

Special No. 4017 rumbles off the north end of the old Clackamas River Bridge in Gladstone. The center entrance doors on the Hollywood cars were permanently closed and additional seating added. That wooden sign in front of the bridge warns, "No Thoroughfare. This is private property. Trespassing hereon is prohibited. P.E.P. Co." Note the block signal at right.

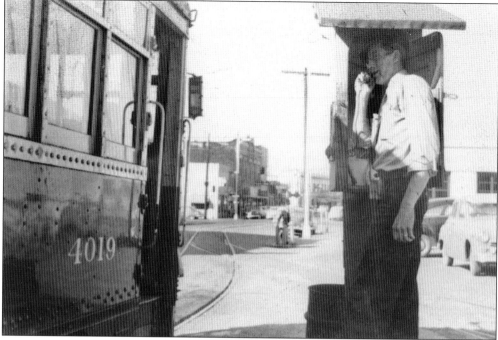

"Let's call the boss." Before departing from the Main Street terminal in Oregon City, the motorman called the dispatcher for clearance. It must be near 1953 since Hollywood No. 4019 still shines in new paint. These cars were geared for 45 miles per hour maximum speeds and were capable of multiple-unit operation.

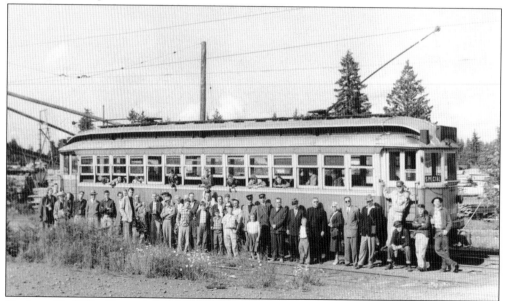

On June 21, 1953, 60 members of the Pacific Northwest Electric Railway Association jammed No. 1101 for a last wooden interurban ride to Cazadero. The photograph was taken by motorman Fred Blaisdell, who had worked for the company since these cars were new. Among the railfans were Charles Hayden (walking in the grass with his hands in his pockets), Kent Haley, and Al Haij (in the center wearing conductor's hats).

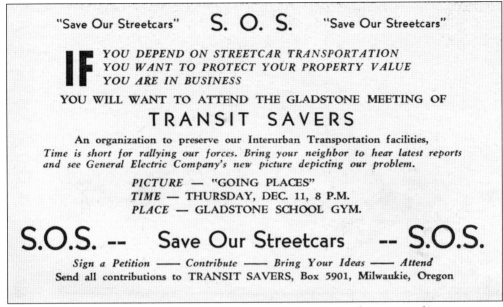

In 1954, 1,200 commuters formed Transit Savers and were instrumental in winning hearings against reduced interurban service. But Portland Traction, owned by San Francisco interests since 1946, wanted to sell to railroads desiring freight-only operation. In September 1956, they allowed the county to build new Hawthorne Bridge ramps without tracks. With ridership dwindling, service was abruptly terminated on January 25, 1958, in defiance of PUC orders.

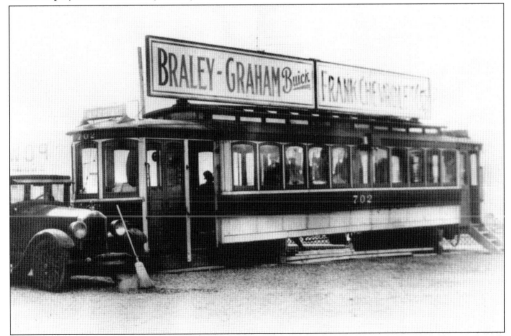

Some streetcar bodies escaped cremation to find new employment, however brief, as diners, beach cabins, chicken coops, and shops. For some years following abandonment of standard-gauge city car service in 1936, old No. 702 was used by Braley and Graham Buick and Frank Chevrolet at their used car lot on Northeast Glisan near Grand Avenue. By 1947, it was gone.

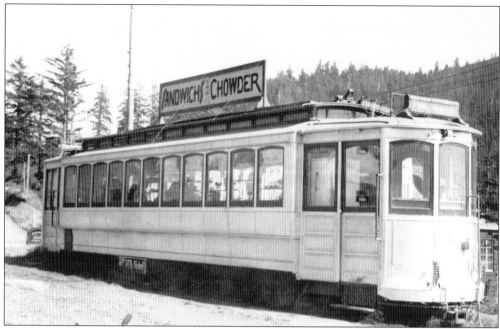

A better fate befell this trolley than that of most Portland streetcars. The former Mount Scott car became a diner on Highway 26 near Elsie. After the end of city service, many such standard-gauge veterans were hauled to Lincoln City or Agate Beach on the Oregon Coast for use as beach cabins. The last of them were gone by the 1980s.

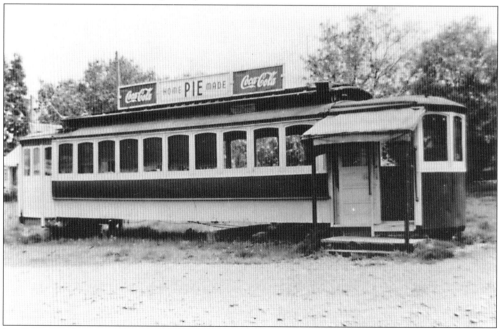

In 1936, standard-gauge Car No. 1351 was stripped of running gear and moved to Three Rocks in Lincoln County to become a diner. It remained there for 35 years before it was moved to Lincoln City, where it is used today as a novelty shop alongside Highway 101. It is, as far as anyone knows, the last surviving Portland streetcar not in a museum or restaurant.

*Eight*

# TROLLEY REDUX
## 1986–PRESENT

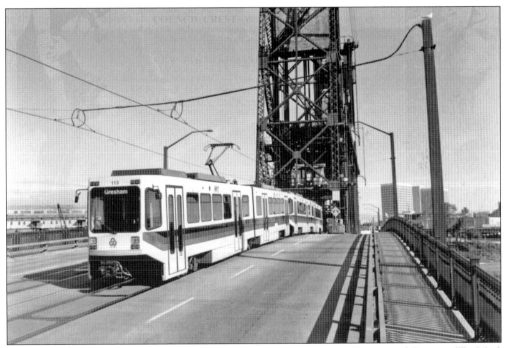

In September 1986, the Tri-County Metropolitan Transportation District of Oregon (Tri-Met) inaugurated the 15-mile Metropolitan Area Express (MAX) light rail line to Gresham. After a hiatus of nearly 30 years, electric railway transit had returned to Portland. Most MAX trains operate in the two-car configuration illustrated in this November 7, 1991, photograph. Car No. 113 and a mate are crossing the Steel Bridge, which is currently the only drawbridge in North America crossed by a streetcar or light rail vehicle (LRV). Tri-Met's first 26 LRVs were built by Bombardier. (Photograph by Steve Morgan.)

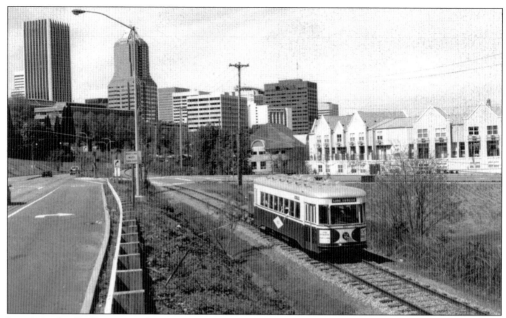

In 1987, the Willamette Shore Trolley began operating between Portland and Lake Oswego, Oregon. Since 1995, the Oregon Electric Railway Historical Society has operated this six-mile heritage railway using cars from its collection and a "tag along" power supply. One of the most popular is ex-Portland Traction Broadway Car No. 813, seen here on the half-mile extension to RiverPlace on its opening day, April 25, 1997. (Photograph by Steve Morgan.)

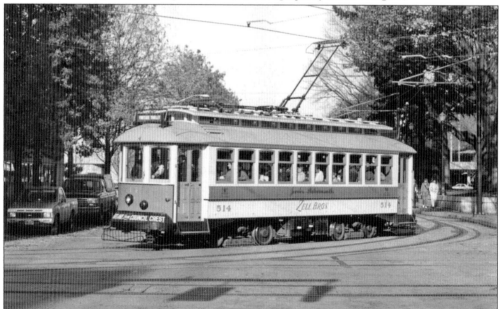

VT No. 514 is turning at Eleventh Avenue and Holladay Street on November 29, 1991, the day Vintage Trolley Incorporated began service between Lloyd Center and downtown Portland using MAX tracks. VTI and Tri-Met, funded by a local improvement district and an Urban Mass Transit Administration grant, contracted with Iowa's Gomaco to construct four Council Crest car replicas. Check out the refurbished PCC trucks. (Photograph by Steve Morgan.)

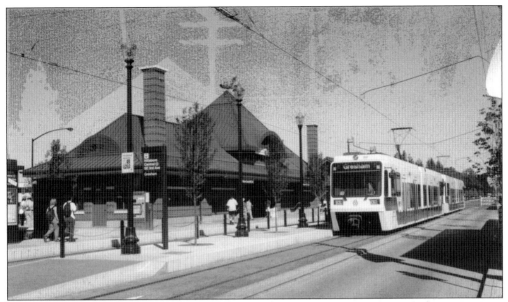

The first major extension of the MAX system was 18 miles west to Hillsboro. Siemens-built, low-floor cars No. 216 and No. 227 are departing for Gresham on September 13, 1998, during the line's opening weekend. The Hillsboro Central/Transit Center, on Washington Street between Third and Fourth Avenues, is evocative of the Oregon Electric Railway station that once stood on the same site. Note the bronze weathervane artwork atop the station. (Photograph by Steve Morgan.)

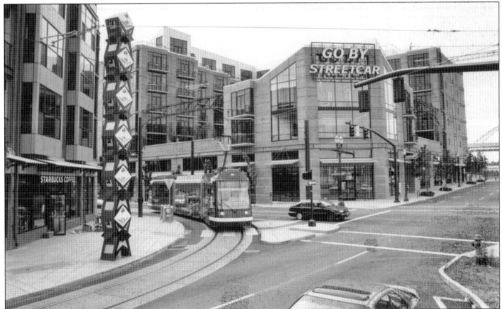

On July 20, 2001, the city-run Portland Streetcar system began operation. The initial route connected downtown with Northwest Portland. Skoda Car No. 001 is pictured here turning onto Northwest Eleventh Avenue from Lovejoy Street in June 2002. The "Go by Streetcar" sign on the new Streetcar Lofts condominiums in the background was inspired by the "Go by Train" sign that adorns the tower of nearby Union Station. (Photograph by Steve Morgan.)

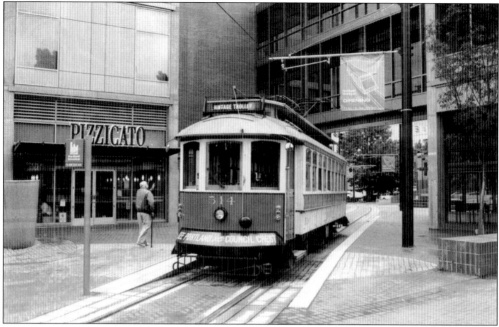

When the Portland Streetcar opened, two of the four Gomaco-built Brill replica trolleys were transferred to the City of Portland from Tri-Met's fleet for weekend use on the new line. Car No. 514 is laying over at the PSU Urban Center on July 28, 2001, during the first day of Vintage Trolley service on the new Portland Streetcar line. (Photograph by Steve Morgan.)

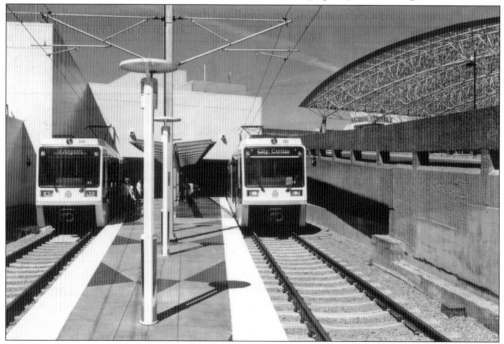

A 5.6-mile extension of MAX, from Gateway to the Portland International Airport, opened on September 10, 2001. Cars No. 249 and No. 220 are pictured here at the new airport MAX (Red Line) terminus on opening day during the first hour of service. (Photograph by Steve Morgan.)

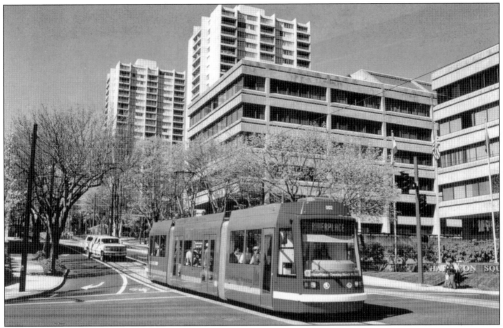

On March 11, 2005, Portland Streetcar service was extended to RiverPlace. Car No. 002 is pictured here on Southwest Harrison Street at Naito Parkway during the second day of operation. Portland Streetcar's first seven modern, low-floor streetcars were built in the Czech Republic by Skoda using an Inekon design. (Photograph by Steve Morgan.)

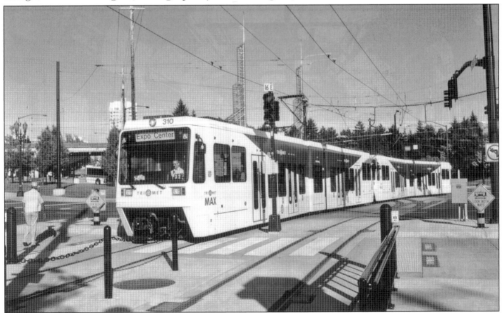

Cars No. 310 and No. 304 are seen entering the third addition to MAX, the 5.8-mile Interstate Avenue Line (Yellow Line), on opening day, May 1, 2004. The convention center towers loom in the background. By 2005, the number of low-floor LRVs, all built by Siemens, had reached 79, and the newest series (301–327) were delivered in the new white, blue, and yellow paint scheme seen here. (Photograph by Steve Morgan.)

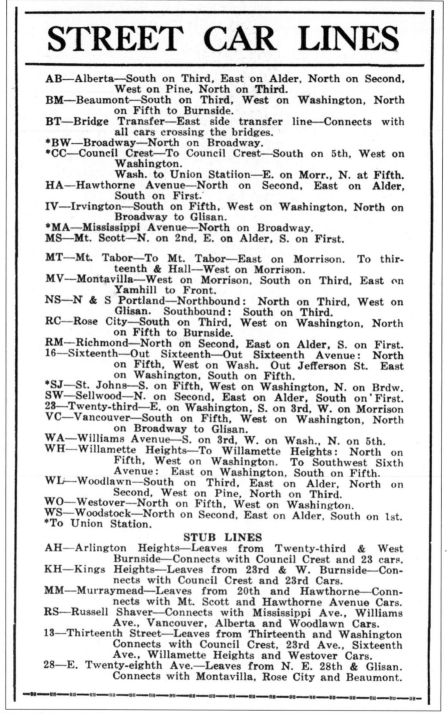

# STREET CAR LINES

AB—Alberta—South on Third, East on Alder, North on Second, West on Pine, North on Third.

BM—Beaumont—South on Third, West on Washington, North on Fifth to Burnside.

BT—Bridge Transfer—East side transfer line—Connects with all cars crossing the bridges.

*BW—Broadway—North on Broadway.

*CC—Council Crest—To Council Crest—South on 5th, West on Washington.
Wash. to Union Statiion—E. on Morr., N. at Fifth.

HA—Hawthorne Avenue—North on Second, East on Alder, South on First.

IV—Irvington—South on Fifth, West on Washington, North on Broadway to Glisan.

*MA—Mississippi Avenue—North on Broadway.

MS—Mt. Scott—N. on 2nd, E. on Alder, S. on First.

MT—Mt. Tabor—To Mt. Tabor—East on Morrison. To thirteenth & Hall—West on Morrison.

MV—Montavilla—West on Morrison, South on Third, East on Yamhill to Front.

NS—N & S Portland—Northbound: North on Third, West on Glisan. Southbound: South on Third.

RC—Rose City—South on Third, West on Washington, North on Fifth to Burnside.

RM—Richmond—North on Second, East on Alder, S. on First.

16—Sixteenth—Out Sixteenth—Out Sixteenth Avenue: North on Fifth, West on Wash. Out Jefferson St. East on Washington, South on Fifth.

*SJ—St. Johns—S. on Fifth, West on Washington, N. on Brdw.

SW—Sellwood—N. on Second, East on Alder, South on First.

23—Twenty-third—E. on Washington, S. on 3rd, W. on Morrison

VC—Vancouver—South on Fifth, West on Washington, North on Broadway to Glisan.

WA—Williams Avenue—S. on 3rd, W. on Wash., N. on 5th.

WH—Willamette Heights—To Willamette Heights: North on Fifth, West on Washington. To Southwest Sixth Avenue: East on Washington, South on Fifth.

WL—Woodlawn—South on Third, East on Alder, North on Second, West on Pine, North on Third.

WO—Westover—North on Fifth, West on Washington.

WS—Woodstock—North on Second, East on Alder, South on 1st.

*To Union Station.

## STUB LINES

AH—Arlington Heights—Leaves from Twenty-third & West Burnside—Connects with Council Crest and 23 cars.

KH—Kings Heights—Leaves from 23rd & W. Burnside—Connects with Council Crest and 23rd Cars.

MM—Murraymead—Leaves from 20th and Hawthorne—Connects with Mt. Scott and Hawthorne Avenue Cars.

RS—Russell Shaver—Connects with Mississippi Ave., Williams Ave., Vancouver, Alberta and Woodlawn Cars.

13—Thirteenth Street—Leaves from Thirteenth and Washington Connects with Council Crest, 23rd Ave., Sixteenth Ave., Willamette Heights and Westover Cars.

28—E. Twenty-eighth Ave.—Leaves from N. E. 28th & Glisan. Connects with Montavilla, Rose City and Beaumont.

In 1933, before buses had begun to replace streetcars on major routes, Portland had 30 city streetcar lines and two interurban lines (Boring and Oregon City). There were also now seven bus lines, all of which were either new routes, stub lines, or crosstown lines. The list above includes line letters and routes running through downtown.